Konica Autoreflex
Manual

Konica Autoreflex Manual

LOU JACOBS, JR.

AMPHOTO
American Photographic Book Publishing Co.
New York

Acknowledgments

My thanks to Mike Green and the personnel at Konica Camera Corporation for supplying both technical data and some of the illustrations in this book including much of the color. Thanks also to Eleanor Bralver for the use of her photographs, and to my editors, John C. Wolf and Norma S. Gindes, who patiently coordinated my words and pictures into logical form.

This Manual is dedicated to all photographers, amateur and professional, who are turned on to the creative use of their Konica Autoreflexes for better seeing and personal fulfillment.

Contents

Chapter I

Introducing the Konica Autoreflex

The Konica Autoreflex is a single-lens reflex camera (SLR), the most popular type of 35mm camera—one that has been refined in its design for many years. Let's look first at the main features that make the SLR unique, or at least very desirable, for the professional and amateur alike.

When you view a scene through the finder, you are looking directly through the lens, via a mirror, a ground glass screen, and a prism (Fig. 1). There is no problem of parallax which may occur with some rangefinder 35mm cameras. With an SLR *you* see the same image the *lens* sees, so you can't accidentally cut off heads or feet.

The range of focus of an SLR is extreme. You can focus an inch or two from an object using a special macro lens, or closeup lenses, or extension bellows.

A large variety of lens focal lengths are available for the SLR, making photography very versatile. You see the image of each lens precisely in the finder, whether it's a wide-angle or telephoto. Zoom and varifocal lenses are also simple to use on the SLR.

An exposure meter is built into the camera for accuracy and speed. The Konica Autoreflex metering system sets your camera in the most ideal, modern, labor-saving manner.

You can check depth of field (the range of sharp focus from front to back in a scene) at any aperture through the SLR finder.

7

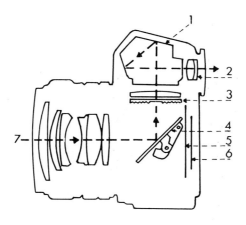

Fig. I-1. Inside the single-lens reflex.

1. Pentaprism 5. Shutter
2. Viewfinder 6. Film
3. Groundglass 7. Light/image
4. Mirror

 A wide range of shutter speeds and lens openings makes photography possible almost anywhere the eye can see. The SLR is also ready for flash via its built-in synchronization.

WHY THE KONICA AUTOREFLEX?

 There are enough reputable SLR's available to make the choice of a camera confusing. If you already own the Autoreflex, the selection was a wise one. If you eventually buy one (or more), I know that you will not regret it, for reasons found throughout this book and from my own experience. Whether you compare the Konica with other SLR's in terms of mechanical operation, reliability, precision optics, lens options, ease of shooting, or price, the Autoreflex is outstanding.

 The Konica Autoreflex was ahead of its time. A few other SLR brands now include automatic exposure, but Konica will always have the edge in terms of experience. Most SLR's still

use the match-needle system that is slower and less consistently accurate.

The single most important reason to choose the Konica Auto-reflex is its fantastic automatic exposure system, which means a minimum of exposure calculation and more "right on" color slides or negatives. Very briefly here's how it works: Two exposure meter cells, located within the viewfinder hump atop the camera, not only determine the correct lens opening for any given lighting condition, but by an ingenious coupling mechanism also *set* the lens opening *automatically* each time you shoot. Since the camera is sensitive to the slightest change of light, you can turn your concentration to composition, timing, and expression.

In use, you choose the shutter speed, the Konica sets the lens opening to match it. There is no need for a hand-held exposure meter, nor do you twist rings and dials to adjust a needle in the finder to set correct exposure. The entire metering system is largely responsible for brilliant color in slides or easily printable negatives. It does extremely well for you.

A BIT OF HISTORY

The Konica automatic exposure system did not spring fully developed from a shell like Botticelli's *Venus*. It was painstakingly invented by several clever engineers around 1962, and first used in a few Konica rangefinder cameras. In 1966 the system was adapted to a Konica single-lens reflex, then called the Auto-Reflex. The camera also incorporated an instant-return mirror and quick-mount bayonet lenses. On the original Auto-Reflex (Fig. 2), the meter "eye" was located at the front of the camera, within the shutter speed dial. It worked fine, but not as accurately at very close distances as the model T and A system that was introduced in 1968 (The model A looks and works in the same way as the model T, but the A has a few less features to reduce its cost. Distinctions are clearly made in Fig. 6 in Chapter II.)

Fig. I-2. The original Auto-Reflex.

In the models A and T Autoreflex, the meter cells were moved inside the camera. Now the meter "reads" exactly the same scene and lighting conditions as the lens projects into the finder, regardless of distance to subject. No matter what focal length lens you use on the Konica, the meter adjusts itself to calculate exposure. The camera is also selective: the meter reads more of the viewing area as longer lenses are used. The advantages of this will be more fully explained.

In 1970 the latest Autoreflex T offered refinements on the original model, such as a shutter-release locking device that also conveniently turns the meter system off and on; a smoother shutter release; and shutter speeds visible in the bottom of the viewfinder. In 1971 the model A was also improved, especially for quieter shutter operation. Konica Hexanon lenses that fit both cameras now include a small locking button that prevents accidentally switching from EE (automatic electric eye exposure) to manual aperture selection.

Current Autoreflex models are shown in Fig. 3 (model T)

Figs. I-3 and 4. The three external features that distinguish the Auto-reflex T are: a shutter lock, a self-timer, and a depth-of-field preview button. The Model A has none of these. Models T and A are identical in their self-setting exposure convenience.

and 4 (model A). There are three external differences to tell them apart: the model T has a shutter lock, a self-timer, and a depth-of-field preview button, none of which are on the model A. Basically, they are identical in their self-setting exposure convenience.

In summary, both Autoreflexes are neatly designed without unnecessary gadgets to boost the price. They are faster to shoot with than almost any other SLR, they each offer a *metal* focal plane shutter (for durability and faster electronic flash syn-

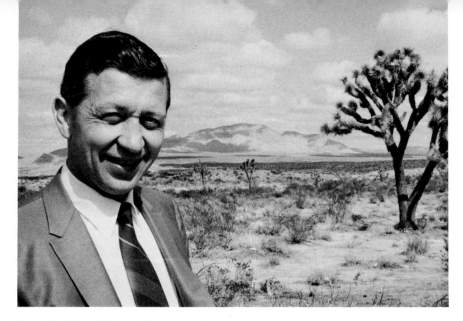

Fig. I-5. The 35mm Hexanon lens provided excellent depth of field for this desert portrait photographed for IBM's *Think* magazine. Exposure was 1/500 sec. at *f*/16 on Tri-X. Overall focus was checked on the depth-of-field scale and with the depth-of-field preview button on the Autoreflex T.

chronization), and are precision made *to last*. Reliability is built into both design and workmanship. Konicas are also lighter in weight than a number of SLR brands, providing the personal comfort that is particularly valued by professionals who often "wear" two cameras, one above the other, at the same time.

PERSONAL

It seems appropriate in a camera guidebook to know something about who is writing it. The manufacturer of the Konica is *not* paying me for this book. I bought my own cameras and lenses before I knew I would be writing a book. Thus, I am independent of the company except for technical data and some illustrations they kindly supplied. The enthusiasm I feel for the Konica is my own, based on plenty of opportunity to make comparisons.

Since 1938 I have been using 35mm cameras, but not until 20 years later did I first own an SLR. I've been a professional photographer since 1950, specializing in pictures for magazines,

books, and industry. During this time I have used several SLR brands. Like most professionals, I was reluctant at first to trust a built-in exposure meter. As a group, pros usually feel that no automation is as accurate as hand-made exposure reading. Due to today's excellent advances in technology, the camera can now "out-think" the photographer.

Though there are many convenient, smooth operating SLR's with fine lenses, parts of this book may sound as though I am trying to sell Konica over all other brands. This is only relative. I genuinely like the Autoreflex and have learned to trust it in my work and for pleasure. If it is also your choice, you will soon realize why I prefer it.

SUMMARY

In later chapters, I mention and show photographs taken with a Konica Autoreflex T by my 12-year-old son. He has only minimal photographic training, but understands the operation of a 35mm SLR so he can focus sharply, load and unload, and shoot in reasonably good light. He learned photography on an earlier camera, but found exposing by the match-needle system somewhat slow. Sometimes in his eagerness to shoot, he forgot to readjust the aperture or shutter speed and was disappointed by washed out or underexposed slides or negatives. Using the Konica has eliminated this hazard. He knows that he should set the shutter speed at 1/125 sec. or faster whenever possible, and he realizes the meaning of depth of field in relation to lens opening—even if he doesn't always apply his comprehension.

With this in mind, I have often thought what a terrific advantage the Konica automatic EE system can be to fairly inexperienced photographers who either want to improve their technique with top-rated equipment, or must shoot for business reasons without the help of a short course. In the latter category could be insurance investigators, real estate salesmen, police photographers, or anyone who wants more versatility than is available

with a Polaroid Land camera, for instance, and can benefit by interchangeable lenses as well. The confidence regarding exposure that the Konica T and A offer, plus all the other easy-viewing and operating features, make these cameras a first choice when picture quality in color and black-and-white are required. In the hands of an amateur who has read this book, or parts of it, the Konica will prevent more mistakes by the user than almost any other popular SLR you can name.

Though a good instruction booklet comes with the Autoreflex, this guide offers a lot more information from a practical standpoint, to clarify and expand your knowledge. It is most advisable to read the instruction manual as well as this manual. I would hope that the versatility and operation of the Konica are more fully and interestingly explained here.

Photography is a language, but it is also a delight when you have equipment that is reliable, precise, easy to handle, and offers a psychological boost. Konica is all of these. It also does more of the work, giving you additional time to consider the nitty-gritty of photography—making outstanding pictures.

Chapter II

Features of the Konica
Autoreflex T and A

Since the Konica Autoreflex T and A models are very similar, I intend to discuss their basic operations together. Both cameras resemble previous models with the same alphabetic designations, though some dealers refer to the later improved models as "T-2" and "A-2"; these are unofficial terms, and the numbers do not appear on the cameras. The tables on the following pages list the differences that distinguish the improved models from their predecessors and from each other.

The Konica Autoreflexes (discussed together from now on, except for specific features) are precision 35mm single-lens reflex cameras with fully automatic through-the-lens (TTL) exposure meter operation. The Konica metal focal plane shutter is sturdier than shutter curtains made of cloth, or even metallized cloth, and synchronizes for electronic flash at 1/125 sec. This is a big advantage for flash-fill (illuminating shadows in outdoor sunlight). Many professionals choose the Konica for this reason among others.

Fig. 1. SPECIAL FEATURES OF KONICAS "A" AND "T"

Feature	Autoreflex T (Improved)	Autoreflex T	Autoreflex A (Improved)	Autoreflex A
Shutter lock combined with meter switch	Yes	Meter lock only on back of camera	No	No
Shutter speed shows in viewfinder	Yes	No	No	No
EE lock on lens aperture ring	Yes	No	Yes	No
Meter EV range (ASA 100, $f/1.2$)	1.5–18	2.5–18	4.5–17	4.5–17
Battery check button	Yes	Yes	No	No
Fastest shutter speed	1/1000 sec.	1/1000 sec.	1/500 sec.	1/500 sec.
Depth-of-field preview button	Yes	Yes	No	No
Self-timer	Yes	Yes	No	No
Black finish available	Yes	Yes	No	No
Quieter shutter operation	Yes	No	Yes	No

The Konica uses standard 35mm film cartridges loaded for 20 or 36 exposures; each frame is 24 × 36mm, or 1″ × 1½″. Konica lenses are mounted or removed in a few seconds by a bayonet system which immediately links each EE (electric eye) lens to the built-in meter. The viewfinder is bright, is easily

adaptable for people with glasses, and includes a micro diaprism in the center for fine focusing. Both shutter speed and lens opening are visible in the finder in the T model. Film is wound and shutter cocked by a smooth, fast stroke of a lever. Double exposures can only be made by a special technique detailed later.

Fig. 2. DIMENSIONS AND WEIGHT: KONICA T AND A

Camera	Lens	Width	Height	Depth	Weight
Konica T	f/1.8	5¾″	3¾″	3½″	33 oz.
Konica A	f/1.8	5¾″	3¾″	3½″	32 oz.
Konica T	f/1.4	5¾″	3¾″	3½″	36 oz.
Konica A	f/1.4	5¾″	3¾″	3½″	35 oz.
Konica T	f/1.2	5¾″	3¾″	3¾″	40 oz.
Konica A	f/1.2	5¾″	3¾″	3¾″	39 oz.

THE ORIGINAL AUTO-REFLEX

In addition to the features mentioned before about this pioneer SLR, there was also a device to divide the picture area and make half-frame (18 × 24mm) slides and negatives. Lenses from this older model can be used on the new Konica, but must be converted by the manufacturer for use with the automatic EE system. As a used camera, the Auto-reflex is still a good buy. You can write the Konica Camera Corporation for an instruction booklet.

OPERATING FEATURES OF THE AUTOREFLEX

On the next two pages, in Figs. 3 and 4, all the operating controls of the Konica T are labeled. Many of these features will be mentioned and described in this and following chapters. A basic familiarity with each item is important to disciplined photography.

Incidentally, I shot the pictures for Figs. 3 and 4, plus some of the other camera details, in my office, using another Konica T fitted with the Macro Hexanon $f/3.5$ lens. A piece of seamless background paper was curved under the camera, behind it, and above it, and two 500W reflector flood bulbs were aimed up at the paper "roof" to bounce a soft light on the camera. I used Plus-X film (ASA 125) and my exposures averaged 1/30 sec. at $f/22$.

Let's continue with the steps necessary to shoot with your Konica Autoreflex.

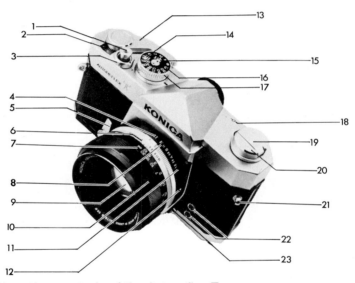

Fig. II-3. Operating controls of the Autoreflex T.

1. Shutter release button
2. Film counter
3. Meter switch and shutter release lock
4. EE mark
5. Self-timer lever
6. Depth-of-field scale
7. Distance scale
8. Optional manual aperture scale
9. Hexanon lens
10. Focusing ring
11. Aperture ring
12. EE lock button
13. Film transport lever
14. Film speed indicator window (ASA)
15. Film speed indicator window (DIN)
16. Shutter speed scale
17. Shutter-speed dial
18. Focal plane mark
19. Film rewind crank
20. Film rewind knob
21. Strap eyelet
22. Flash synch outlets "X" and "M"
23. Lens release button

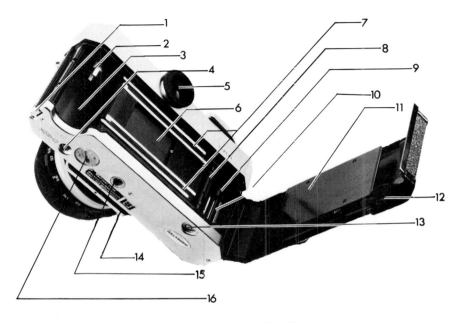

Fig. II-4. Operating controls of the Autoreflex T.

1. Back cover lock
2. Film rewind spindle
3. Film cartridge chamber
4. Battery check button
5. Eyepiece
6. Shutter
7. Film guide
8. Sprocket
9. Film take-up spool
10. Film take-up slits
11. Pressure plate
12. Back cover
13. Film rewind button
14. Depth-of-field button
15. Tripod socket
16. Mercury battery chamber

INSERTING BATTERIES

Without its two tiny mercury batteries, the Konica is "blind," and won't start any more than a car will without its battery. In the bottom of the camera is a battery chamber. It opens when turned counterclockwise with a coin. Insert two Mallory No. PX-675 or Eveready EPX-675 (or equivalent) 1.3v mercury batteries plus-side up, as shown in Fig. 5. Handle the batteries by the edges, because oil from your fingers may impair contact. Wipe them with a soft, dry cloth if necessary. With the batteries

Fig. II-5. The Autoreflex uses either the Mallory No. PX-675 or the Eveready EPX-675 1.3v mercury batteries, inserted plus-side up.

in position, screw the cover back in place firmly. Now the CdS (cadmium sulfide) cells within the camera have the power to measure light and set the lens opening for you.

Mercury batteries should last about a year in normal use. Battery voltage drops abruptly when they are weak, and soon the meter needle in the finder stops moving. When you have used your camera the better part of a year, carry a couple of new batteries in your gadget bag for easy replacement. Be sure they are 1.3v mercury batteries. A lot of little batteries look alike, but are not the same voltage, and might result in incorrect exposures. If you wish to store your Konica for a long period, remove the batteries and store them with the camera in a cool, dry place.

Battery check

When in doubt about remaining battery life with the Konica T, here are the simple steps to check them:

1. Remove the EE lens by pressing the lens-release button in front at the edge of the lens mount, turn the lens barrel counterclockwise, and extract it. (It is not necessary to remove *non-EE* lenses to check battery power.)

2. Set film speed to ASA 100 by lifting the outer ring around the shutter speed dial, and turning it.

3. Set shutter speed to 1/125 sec.

4. Press the red battery-check button on the underside of the camera, while looking through the viewfinder. If the needle stops at the battery-check mark between $f/8$ and $f/11$, or glides toward $f/16$, your batteries are okay. If not, replace them. Batteries may be checked with the meter switch (on the Konica T) in the "on" (red dot) or "off" (L) position.

LOADING THE CAMERA

Find a shady spot or shield the camera in the shadow of your body. Film loading is fast and positive in the Konica:

1. Open the back cover of the camera by pulling the latch down with a fingernail.

2. Slip the film cartridge into its chamber at left as shown in Fig. 6. There's no need to lift the film rewind knob, which doesn't lift anyway.

3. Pull the film leader across the picture frame opening and insert it into *any* slot in the film take-up spool. Konica calls this Insta-Grip loading, and it's practically foolproof.

4. Advance the film-transport lever as far as it will go. Be sure the sprocket holes in the film are fitted to the sprockets, and close the camera.

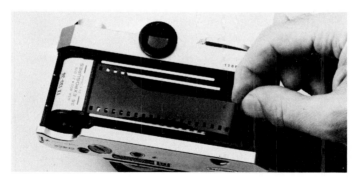

Fig. II-6. After you place the film cartridge into its chamber, insert the film leader into any slot in the take-up spool.

5. Advance the film transport lever three times, pressing the shutter release button between turns, until "1" appears opposite the mark in the film counter window. Make a habit of watching the take-up knob move as you do this; if by chance the film leader has slipped from the Insta-Grip take-up reel, the rewind knob will not revolve. Give it a few turns to the right, and if there is no tension, open the camera back again and check the leader. A mistake at this point can be extremely frustrating later, because the film counter works, and you may think you are taking pictures though the film is not winding through the camera. Return the shutter release lock (on the model T) to "L" (lock) until you are ready to shoot pictures. This reduces battery wear, and prevents accidental exposures. On the Konica A, replace the lens cap to save the meter batteries.

FILM ADVANCE AND REWIND

One stroke of the film transport lever moves the film one frame forward, cocks the shutter, and advances the film counter. Numbers on the counter run to 38, with 20 in red for shorter film rolls. Should you wish to remove a roll of film before it is completely exposed, note the frame number, and rewind according to instructions below. Stop rewinding when tension on the knob indicates the film leader is about to pop away from the take-up spool. Open the camera, mark the film with the number of frames exposed, and switch to another roll. Later you can re-load the unfinished roll, advance the film and fire the shutter *with the lens cap on,* until you are one frame beyond the number where you stopped. The added frame is a safety measure, since frame 1 does not always start in exactly the same place on each roll. Be sure to mark partly exposed rolls clearly, or you will have some embarrassing double exposures.

Rewinding the film

When you reach the end of a roll, the film transport lever won't move a full stroke and the shutter won't cock. Watch the

film counter; as the last frame is exposed you will know not to force the advance lever, because you could tear the film and possibly damage the camera. If the film does tear before rewinding, you'll have to unload the camera in total darkness, and store the loose film in a light-tight container. You won't be the first careless photographer to whom this has ever happened. It's a lesson that will help prevent over-winding again.

Here's the rewinding procedure:

1. Depress the film rewind button on the bottom of the camera. It should stay down. But if it doesn't, push it more positively.

2. Lift the film rewind crank within the knob and turn it in the direction of the arrow on the underside of the crank.

3. When rewinding is complete, you'll hear the film leader pop out of the take-up spool, and the rewind knob will turn very freely. Now you can open the back of the camera—in the shade, please. Remove the cartridge past the convenient half-moon opening in the camera bottom. Store the film in a metal canister, or in its original wrapping to prevent stray light from seeping into the cartridge, causing fog or streaks.

4. The film rewind button will pop out when you next turn the film transport lever, which is a good idea, if you are not immediately reloading the camera. Depress the shutter release (known as firing the shutter), before you put your camera away. *This is important.* When the shutter is not cocked, the delicate springs that regulate shutter speeds will be relaxed, and last longer. Springs in tension (because the shutter is cocked) for days or weeks while the camera is stored will reduce shutter reliability eventually. Replace the lens cap, also, when you put the camera away.

5. The film counter returns to "S" (start) by itself when the back is opened, and the camera is ready to go again.

6. Keep a soft brush handy to sweep the inside of the camera lightly after a day's shooting, and blow out dust between rolls of film as a matter of habit. Tiny bits of film may break off at the sprocket holes to jam the camera or cause scratches on subse-

quent rolls. Spotless prints and slides are your reward for cleanliness. Any camera repairman will tell you how many fine cameras are damaged by tiny bits of film, dirt, or sand that should have been blown or brushed away.

All the controls mentioned above (except the film rewind button) and most of those described below are seen in Fig. 7.

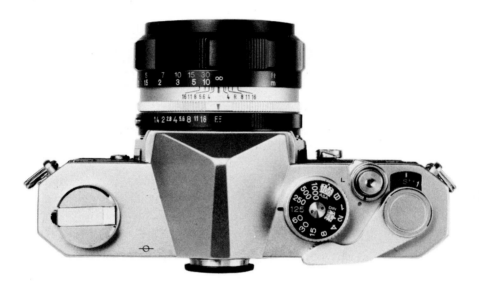

Fig. II-7. Top view of the controls of the Autoreflex.

SHUTTER AND APERTURE

Before I tackle the wonders of exposure automation offered by the Konica Autoreflex, here are the controls involved:

Shutter

The all-metal shutter curtain is called a Copal Square S focal plane shutter. It moves like a window blind that snaps across the film plane for a pre-determined fraction of a second represented by numbers on the shutter speed dial. Each speed is *double* the one before it, or *half* the one after it; intermediate

speeds cannot be set between clicks. However, the dial may be turned before or after cocking the shutter.

"B" on the shutter speed dial represents bulb, a term handed down from decades ago when a photographer squeezed a bulb at the end of a rubber tube to activate a shutter. Bulb is used to make exposures longer than one second, i.e. time exposures. The shutter stays open from the time you depress the release until pressure on the button is removed. For exposures longer than a few seconds, use a cable release, such as one that locks to save you from holding it a long time. Obviously, the camera must be supported on a tripod or other steady base during time exposures.

Fig. II-8. This hand-held shot was taken in a dimly lit railroad station with the 52mm Hexanon at 1/15 sec. at f/2.8 on Tri-X.

You may have heard that a tripod, or other support, is necessary for exposures longer than 1/30 sec. It is clear that shutter speeds such as 1/125 sec. or faster are recommended to reduce the possibility of blurred images due to camera movement—and to stop action as well. However, the experienced photographer learns to hold the Konica at slower shutter speeds in emergencies. Fig. 8 was shot at 1/15 sec., hand-held in a railroad station where the light was weak. The 52mm Hexanon lens was set at $f/2.8$, and the film was Tri-X (ASA 400). The image is not critically sharp, but it's certainly satisfactory. Photography is also possible at 1/8 sec. hand-held if you learn to hold your breath during the exposure, and grasp the camera firmly. Since a certain amount of camera movement is inevitable at such slow speeds, shoot a number of frames if possible to beat the law of averages.

As described later, the sensitivity of the Konica CdS exposure meter has certain limits in very dim light. Use of manual aperture settings is covered in a following section. In such a case you must guess exposure or use a very sensitive hand-held CdS meter when the EE system is not operating.

Aperture

Both the speed of the shutter and the lens opening (also called the aperture or diaphragm opening) determine the amount of light that strikes the film. The size of the lens opening is indicated in $f/$stops, marked on the ring closest to the camera body on the lens barrel, from the widest aperture of your lens to the smallest, usually $f/16$. The ratio of $f/$stop numbers to the amount of light they admit into the camera is shown in the numbers and fractions at the bottom of Fig. 9. As you will note, the smaller the $f/$number, the larger the lens opening. Each full "stop," the term that describes the numbers at the top of Fig. 9, offers *double* the exposure of the previous stop (as the numbers get smaller), or *half* the exposure (as the numbers get larger).

To watch your lens aperture operate, remove the lens from the camera and look through it while turning the diaphragm

ring. As openings get smaller, it is called *stopping down;* as they get larger, you are *opening up* the iris diaphragm.

The aperture ring of a Hexanon lens clicks into place at each of the full stop numbers printed on the barrel (shown at the top of Fig. 9). The ring also clicks into place between these numbers at *half-stops,* which indicate one-half more, or less, exposure, depending on whether you are opening up or stopping down.

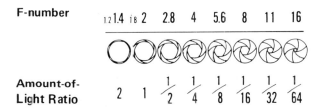

Fig. II-9. Amount of light and aperture. As the f/number (top row) increases, the diaphragm closes down and admits less light, half as much for each stop (bottom row).

Aperture selection for correct exposure is done by the Konica Autoreflex EE system for you. Though you see the indicator needle in the camera finder setting itself effortlessly, you should be familiar with the relationships of aperture openings.

AEC—AUTOMATIC EXPOSURE CONTROL
IN OPERATION

When you study the schematic diagrams in Figs. 10 and 11, showing the Konica T and A metering systems, you are looking into the "vital organs" of this precision camera. In brief, here is how the ingenious electro-mechanical series of components works:

1. The meter switch is turned on (T model only), allowing the flow of electricity from batteries to resistors and the CdS cells within the prism dome.

2. Both CdS cells measure the amount of light coming

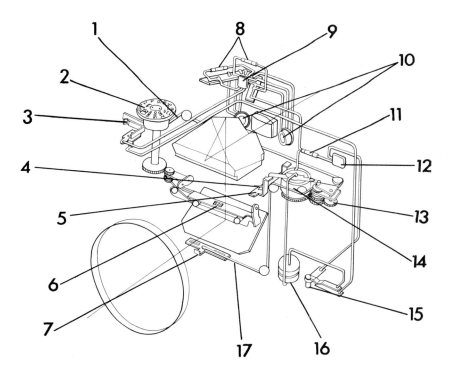

Fig. II-10. Konica Autoreflex T metering system.

1. Shutter and film speed coupling
2. Shutter- and film-speed dial
3. Meter switch
4. Meter needle
5. Mark for indication of f/stop at full lens opening
6. Shutter speed scale
7. Lever for transfer of f/stop at full lens opening
8. Compensating resistor
9. Variable resistor
10. Compound CdS cells
11. Compensating resistors
12. Variable resistor
13. Differential gear
14. Meter
15. Battery check
16. Mercury batteries
17. f/stop coupler

through the lens and reflected to the cells by the mirror through the ground glass at the base of the prism.

3. Switches, gears, other resistors and small metal forks at the edge of the lens opening in the camera body translate the meter's measurement into the correct lens opening, depending on the shutter speed selected.

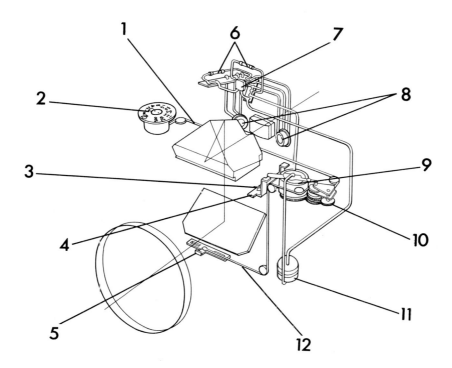

Fig. II-11. Konica Autoreflex A metering system.

1. Shutter and film speed coupling
2. Shutter- and film-speed dial
3. Meter needle
4. Mark for indication of f/stop at full lens opening
5. Lever for transfer of f/stop at full lens opening
6. Compensating resistors
7. Variable resistor
8. Compound CdS cells
9. Meter
10. Differential gear
11. Mercury batteries
12. f/stop coupler

 4. Within the finder, a needle shows you the diaphragm setting that the meter determines will provide perfect exposure for the scene in view. In the model T Konica, shutter speed is also indicated at the bottom of the finder. If you change the speed, the aperture indicator needle moves up or down instantly via the f/stop coupler in back of the mirror.
 5. When the shutter button is depressed, the f/stop coupler,

along with an assortment of springs within the camera, is tripped to close the iris diaphragm to the f/stop shown by the meter needle, which seems to freeze into place at the moment of exposure. The shutter curtain snaps across the film plane at the precise moment the lens is stopped down to the proper opening. After exposure, the shutter curtain comes to rest completely across the opening in front of the film, which explains why you can remove and replace a lens without affecting the film at all. The diaphragm automatically returns to full opening for brightest focusing conditions.

A fraction of a second before this electro-mechanical magic takes place, the mirror snaps up and out of the way to allow the image coming through the lens complete access to the film. As you shoot, the click you hear is both the mirror flipping up and down and the shutter in action. Both are insulated by sound and vibration-absorbing materials to provide steady, quiet operation.

6. You cock the shutter and advance the film to ready the camera for another picture. During this time, the EE system is always ready to make instant decisions about exposure. Notice how the needle in the finder varies, even minutely, as lighting conditions or camera angle change. This is the key to consistently excellent exposure which automatically frees you to concentrate on composition and pictorial distinction.

THE KONICA VIEWFINDER

Konica calls its camera finder the "control center," though it might more accurately be the instrument panel that shows quickly and neatly how your camera controls are set. Let's examine the finder (Fig. 12), which also happens to be a clear window on the world through which you see what the scene or subject is all about as you photograph.

1. At the right is the needle that indicates in f/stops the intensity of the light as it is constantly monitored by the sensitive built-in CdS meter cells. Starting at the top:

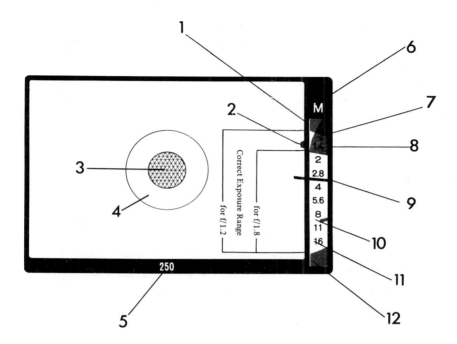

Fig. II-12. Autoreflex viewfinder.

1. Underexposure warning for f/1.2 lens
2. Optional stopped-down metering index mark
3. Micro diaprism
4. Fine groundglass area
5. Shutter speed scale
6. When in non-automatic exposure mode an "M" appears here
7. f/1.2 mark
8. Maximum aperture indicator
9. Meter needle
10. Battery check mark
11. Aperture scale
12. Overexposure warning

"M" appears in the corner when you turn the aperture ring from "EE" to any f/stop, or use a non-EE lens. "M" means manual, reminding you that the camera is not self-setting, even though the meter needle is still registering.

The shaded area (a red band in the camera) above the f/stop numbers indicates maximum aperture of the lens in use. As lenses are changed, this colored area is adjusted automatically to remind you that f/1.8 or f/2.8, for instance, are the widest openings available.

The upper red area remains constant and applies only to the $f/1.2$ Hexanon lens. Underexposure will result if the needle swings into this upper area. Overexposure is shown when the needle moves into the bottom red area—except when you use a lens that stops down to $f/22$, such as the Macro Hexanon. For instance, with a fast film, the needle will be into the bottom red zone in bright light until you have set the shutter speed high enough.

The little bump, or index mark, opposite the $f/1.4$ setting is used for stopped-down metering with non-EE lenses. Further explanation is coming.

When the needle appears anywhere in the white area of the $f/$stop scale, it means you have enough light to shoot, though you may have to brace your camera for slow shutter speeds.

The little red line on the Konica T scale, between $f/8$ and $f/11$, is the battery check mark described before.

2. The shutter speed, seen in the bottom margin of the model T finder, shows up best when the light is medium bright or very bright.

3. In the center of the finder is a small spot called the micro diaprism, which consists of many tiny prismatic forms. Within this spot you precisely focus the lens. When an image is out of focus, the spot shows a muddled pattern which becomes crisp when sharp focus is attained. Even a slight turn of the lens will show up the difference between in-focus and out-of-focus on the micro diaprism.

The plain ground glass circle around the center diaprism spot magnifies texture slightly when you focus on a patterned surface.

The complete finder is used for composing, and overall focusing; depth of field is checked here on the Konica T as well. Keep in mind that a scene or a person is miniaturized in the finder, which must be used as accurately as possible for both focus and seeing.

The finder in use

No matter if you are shooting with an automatic EE lens, or with the stopped-down method described shortly, here is the way to put the Konica "control center" to work:

1. Set the film speed by lifting and turning the outer collar around the shutter-speed dial. Film speed values in ASA and DIN ratings are shown in Fig. 13. Numbers in brackets are represented by unnumbered marks between numbers. You can set the dial for any appropriate speed into which it clicks.

	(1250)(1000)(640)(500)	(320)(250)	(160)(125)	(80)(64)	(40)(32)	
ASA	1600 . . 800 . .	400 . .	200 . .	100 . .	50 . .	25
DIN	33 . . 30 . .	27 . .	24 . .	21 . .	18 . .	15
	(32)(31) (29)(28)	(26)(25)	(23)(20)	(20)(19)	(17)(16)	

Fig. II-13. Film-speed dial ratings. Numbers in brackets are indicated by dots on the film-speed dial of the Autoreflex.

2. Choose a shutter speed appropriate for the intensity of light, the action, and the steadiness of your hands. Remember that faster speeds disguise camera movement, which spoils more pictures for beginners than any other cause.

3. Turn the meter switch (on the Konica T) to the "on" position at the red dot.

4. Where is the meter needle? If it's up or down in the red zones, turn the shutter-speed dial accordingly: when it's up, you need a slower shutter speed, and when it's down, you must shoot faster. If you cannot get the needle to move within the white area, pictures cannot be made using the EE system. You may be able to set the aperture manually as described shortly.

If you wish to use a specific lens opening, such as $f/11$ or $f/16$ for greater depth of field, or a larger aperture such as $f/2.8$ or $f/4$ to throw a background out of focus, turn the shutter-speed dial until the needle indicates the opening you want.

Notes of caution

Be sure the aperture ring on the lens is set on "EE," if that's

where you want it. If you see the small "M" in the top right corner of the finder, it will remind you you're not on "EE," though the meter needle shows correct exposure anyway. At first, it is not uncommon to experience over- or underexposure, because you see the needle moving, and assume it is automatically linked to the aperture.

Between pictures, turn the meter switch to the "L" position on the model T, or replace the lens cap on the model A, to save battery power.

Remember that the Konica T operates on "EE" at any shutter speed (depending on film rating explained below), but the Konica A operates automatically (regardless of film speed) from 1/15 sec. to 1/500 sec. only. Yellow numbers on the model A shutter-speed dial (B, 1, ½, ¼, and ⅛) do not couple for EE operation.

STOPPED-DOWN EXPOSURE METERING

When you use a lens having a manual or pre-set diaphragm, and no EE setting, here is the operational sequence:

1. Set the film speed as noted before.
2. Choose an appropriate shutter speed.
3. Turn the model T meter switch on.
4. Turn the aperture ring left or right until the meter needle lines up with the index mark next to the $f/1.4$ setting on the finder scale. Now the camera's built-in meter has measured the light and indicated via the needle at the stopped-down aperture mark that you have the correct lens opening and shutter speed settings. Of course, you can adjust the shutter speed to bring the needle to the mark as well.

By using the correct Konica lens adaptor, you can mount literally hundreds of lenses on the T or A models, and still enjoy the advantages of the built-in meter. Among lenses that can be adapted are certain Hexanons, or those made for the Konica FP, Pentax, Praktica, Exacta, or Nikon.

The stopped-down metering system is also used when extension tubes or a bellows separate the lens from the camera body for closeups, making the EE system inoperative. In photomicrography the meter needle is brought to the index mark by adjusting the shutter speed and the light.

When using Hexanon, or other brand mirror reflex lenses, which have a fixed aperture, turn the shutter-speed dial and/or use neutral density filters to bring the meter needle to the index mark.

Manual exposure on EE lenses

If you wish to set the camera for an offbeat exposure, you must override the EE system. Move the diaphragm ring from EE to the f/stop desired, using the meter reading as a guide. For instance, at a night graduation exercise, using a 135mm Hexanon, my meter showed $f/2$ on the finder scale (at 1/30

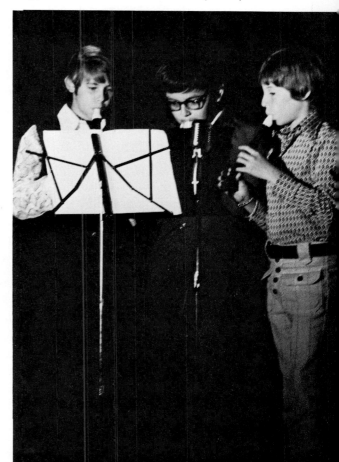

Fig. II-14. If you want an offbeat exposure such as this one, you must override the EE system; 135mm Hexanon at 1/30 sec. at $f/4$.

sec.) for the three youngsters in Fig. 14. I realized that this exposure would give my negatives too much density in the highlights, so I set the lens at $f/4$. Shadow detail was somewhat decreased, but highlights were easily printed.

Note: The latest Hexanon lenses include a small lock button on the aperture setting ring which prevents movement from "EE" to an f/stop accidentally. Depress the button to turn the ring; when you move it back, it will click into place at "EE."

DEPTH OF FIELD

Depth of field is the distance, or area, between the *nearest* and *farthest* objects in a scene *that will be in sharp focus* in the finished slide or print. There are three things that govern depth of field: the aperture of the lens, the focal length of the lens, and the distance at which the lens is focused. With a couple of examples, let's take these one at a time.

Aperture

The larger the lens opening, the less depth of field you get in a photograph. As an optical principle, the area in focus increases as a lens diaphragm is stopped down. To check this, on the lens barrel of each Hexanon lens is a depth-of-field scale illustrated in Fig. 15. Note an identical series of aperture numbers on both sides of the center index mark. As you focus, depth of field for any lens opening is indicated between the f/number on the left and its twin on the right. For instance, if you focus the 52mm Hexanon lens in Fig. 15 at 7 feet, the 5-foot mark will fall opposite the $f/16$ mark at left, and the 11-foot mark will fall opposite the $f/16$ mark at right. Approximate depth of field is therefore about 6 feet at $f/16$, focused at 7 feet.

I said "approximate" above because really precise measurements for depth of field have been charted for various apertures and distances; a few of these depth-of-field tables will be found in Chapter VIII. Studying a depth-of-field table for your lens(es) can be revealing. You'll note that the opposite of what I said

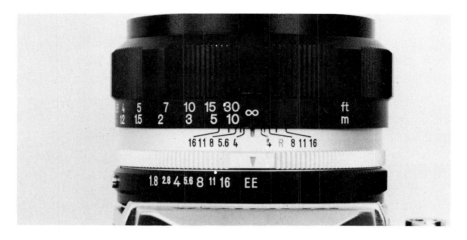

Fig. II-15. All Hexanon lenses have a depth-of-field scale inscribed on the lens barrel.

at the start of this section is also true: *the smaller the lens opening, the greater the depth of field.* Using the 52mm Hexanon again as an example, look at this comparison:

Focused at 10 feet / aperture $f/2$ / depth of field is 9.3' to 10.7'.

Focused at 10 feet / aperture $f/16$ / depth of field is now 6.5' to 21.9'.

Just stopping down from $f/2$ to $f/16$ increased depth of field from mere inches to 15 feet. It is apparent that if you want deep sharp focus on a scene, a small lens opening is called for; conversely, if you want shallow focus, or depth of field, a large lens opening will usually do it.

Focal length of the lens

By definition, lens focal length is measured from the center of the lens to the film plane (more or less), usually in millimeters. Technically, focal length measurement is more complex than I've stated. What is important to you are the distinguishing characteristics between lenses of different focal lengths. Here is a fast list with which to categorize lenses, the focal lengths of

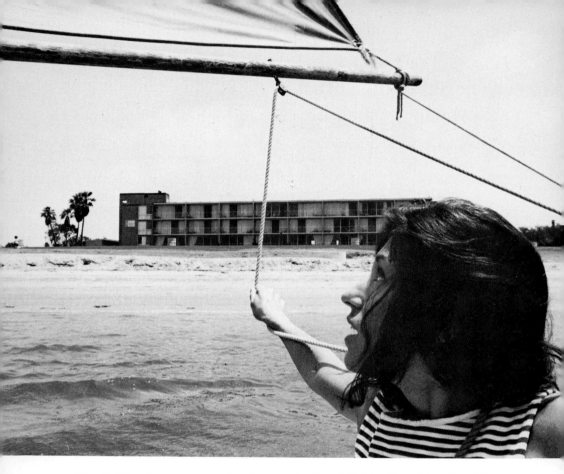

Fig. II-16. An example of extreme depth of field offered by the 28mm Hexanon f/3.5 lens.

which are all marked very neatly on the rear of each Hexanon barrel next to the red dot:

Short focal length lenses, also called wide-angle lenses: 21mm, 28mm, 35mm.

Medium focal length lenses: 52mm, 57mm, 85mm, 100mm.

Long focal length lenses, sometimes called telephoto lenses: 135mm, 200mm, 300mm, and anything longer.

A couple of optical absolutes

The shorter the focal length of a lens, the greater the depth of field it produces at any given aperture. The greater the focal length of a lens, the less depth of field it produces at any given aperture.

It should thus be clear that if you want deep focus, or plenty of depth of field in a picture, you must use either a fairly short focal length lens, a small aperture, or both. Fig. 16 is a sample of extreme depth of field offered by the Hexanon 28mm $f/3.5$ lens. My wife was only 2.5 feet from me in a small sailboat, and the hotel in the background was at the infinity setting. With the lens focused at 5 feet, the area of sharp focus started at 2.5 feet and extended to infinity at $f/16$. Had I used a longer focal length lens, I would have either had to move back a few feet (into San Diego Bay) or be satisfied with a sharp wife and a fuzzy hotel.

Now look at Fig. 17 taken with the Hexanon 80~200mm zoom focused about 15 feet, set at $f/11$ and about 180mm. Depth of field is comparatively shallow because this is a telephoto lens focused fairly close. However, I wanted the bird sharp along with the foreground railing, and I chose to let the railing go fuzzy in the background for pictorial effect. In other words, the photographer is in *control* of the optical principles which determine depth of field, and pictures may be enhanced by your awareness of aperture, focal length, and focusing distance.

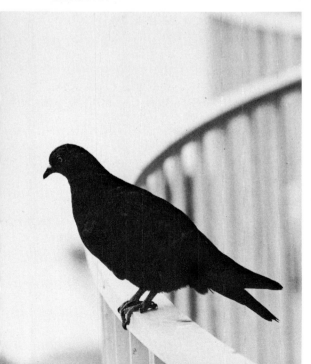

Fig. II-17. Shallow depth of field. Taken with the Hexanon 80~200mm zoom lens set at $f/11$ and about 180mm.

Focusing distance

The way this component integrates into the depth-of-field story has been included above. As a summary: the closer you focus to any object, the less inherent depth of field a lens produces. In reverse, the farther you focus from the lens, the greater the depth of field, due to optical principles.

An additional note: Depth of field increases faster *behind* the point of focus than in front of it. Using the 52mm Hexanon again as an example, at $f/16$, focused at five feet, depth of field extends forward to four feet, and goes almost seven feet into the distance. If you keep this in mind, you will choose your points of focus as a habit, to provide the depth of field that each picture situation needs.

In summary, depth of field may sound mysterious or tricky at first, but it is easy to visualize when you are aware of how picture sharpness is caused and controlled. If you shoot a distant scene focused at infinity, you'll have overall sharpness at any lens opening, providing no object is closer than 100 feet or so. (Keep in mind that a lens is not as sharp wide open as it becomes at about $f/4$ and afterwards. More of this in the next chapter.) And if you shoot closeups, even at the smallest lens aperture, your depth of field is measured in inches, not feet.

Depth-of-field preview

Using the Konica Autoreflex T, there is a method of observing depth of field, *approximately*, with the depth-of-field preview button, by these two steps:

1. Depress the shutter release button *partially*, thereby locking the meter needle and diaphragm at the appropriate aperture selected by the EE system.

2. With the forefinger of your left hand, depress the depth-of-field button in front of the camera next to the lens. The aperture will stop down to the $f/$number indicated by the meter needle, and you can view the area of your scene in sharp focus, i.e. preview the depth of field.

The viewfinder image darkens when you preview depth of field, due to the smaller aperture. Keep in mind that the limits of sharp focus are only approximate, because the scene is miniaturized in the finder. Focus changes more quickly from sharp to fuzzy than you can visualize in the finder. In an enlarged print or slide, focus drops off more gradually, so an object may be almost sharp, and quite satisfactory. For more precision, use the depth-of-field scale on the lens barrel to check the preview seen through the lens.

Fig. 18 by Eleanor Bralver demonstrates a depth-of-field problem she encountered at a baseball game. Seated in the stands, using a 100mm Hexanon lens, she focused on third base, which was 40 feet away. Setting her shutter speed at 1/500 sec., the meter needle indicated $f/16$. She turned the lens barrel to put the infinity mark opposite the right-hand $f/16$ setting on the depth-of-field scale. At that point she saw 30 feet opposite the left-hand $f/16$ mark. Then she waited for this exciting action in the game, knowing she did not have to focus again in order to assure that both the foreground and the people in the stands would be sharp. Many picture situations lend themselves to pre-setting the focus in the same way.

Fig. II-18. Eleanor Bralver pre-focused her camera to catch this exciting action; 100mm Hexanon lens at 1/500 sec. at f/16.

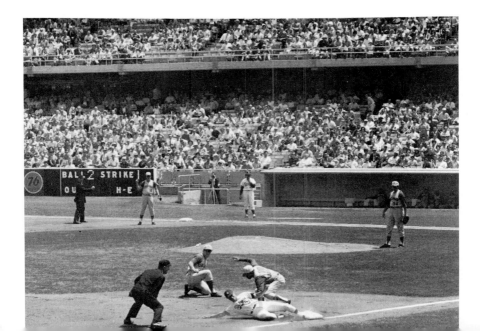

It is more difficult to judge both sharpness and depth of field through the finder with a wide-angle lens than with a medium or telephoto lens. A wide-angle lens has such great inherent depth of field that overall sharpness may seem to exist at some distances, even if the lens is wide open. You *can* focus accurately with the micro prism spot, but pre-setting focus on the depth-of-field scale of a wide-angle lens is usually preferable.

When you use the stopped-down or manual method of exposure (rather than EE), you need not depress the shutter release button of the Konica T. Merely press the front depth-of-field preview button to preview depth of field while setting the desired aperture.

Using depth of field

If you want extensive depth of field:
1. Choose a wide-angle lens.
2. Use a small aperture and focus carefully.
If you want to decrease depth of field:
1. Choose a longer than normal (52mm or 57mm) focal length lens, especially for portraits, when you may want the background out of focus.
2. Use a large aperture, such as $f/2.8$ or $f/3.5$.
3. Use neutral density filters to decrease film speed and make larger apertures possible, particularly if you must shoot with a wide-angle lens.

SELF-TIMER

The self-timer on the Konica T (called the "tricky timer" by one of my sons) has several functions. When you want to set the camera on a tripod, or other steady support, and get into the picture yourself, it's a breeze. Focus the camera and compose, leaving room for yourself. Cock the shutter and turn the self-timer lever in front of the camera to its farthest position. Now depress the shutter release, and you have ten seconds to shift into the picture before the self-timer fires the camera.

Another trick the self-timer accomplishes is firing the shutter when you must hold the camera in your hands at slow shutter speeds. You may cock the self-timer lever only part way to decrease the delay. This will prevent some, but not all, camera movement, which is inevitable for any normal, breathing human photographer at 1/15 sec. or slower. In addition, use the self-timer when the camera is on a tripod and you have no cable release, to eliminate hand contact with the shutter-release button at the time of exposure.

Accessory self-timers are available for use with the Konica A. Such a gadget screws into the cable release socket in the center of the shutter-release button. An accessory self-timer can be set for a delay of 20 seconds. In operation a small plunger slowly lowers itself into the socket and fires the shutter at the selected time delay. Be sure the plunger is adjusted correctly so it does not damage the camera.

MISCELLANEOUS NOTES

Covering the finder

When you use a camera with built-in exposure meter, it is advisable to keep your eye as close as possible to the eyepiece of the finder. This prevents extraneous light, which might cause a slight error in exposure, from entering the finder and reaching the meter cells. That's what the instruction booklet advises, but though I wear glasses, which prevents my burying the eyepiece closely in my eye socket, I have seen no evidence of negatives or slides being affected.

The Konica T manufacturer also advises that when you use the camera on self-timer you cover the eyepiece with a piece of tape before making an exposure. I'm not certain this is necessary, but to play it safe, experiment at least. Also, don't stand directly in front of the lens when releasing the shutter on the self-timer position, since the EE system will be measuring you or your shadow as the shutter release is depressed, rather than the scene to be photographed. This could lead to over- or underexposure.

Fig. II-19. No attempt was made to make the silhouetted foreground figure any sharper, because the 100mm Hexanon lens at this range does not offer such a wide depth of field. In any case, it is the distant figures and action that must be sharp.

EE coupling range on the Konica T

Switch on your camera meter and set the film speed for the type of film you use most often. Point the camera into a darkened area, and turn the shutter-speed dial to progressively lower speeds. Notice how the top red maximum aperture indicator moves down, until with the $f/1.8$ lens, it may rest at $f/4$ when you are set at one second. The EE system is helpfully compensating for the sensitivity of the CdS meter to show the widest opening at which you can use the EE setting for a given film speed.

Since the meter's sensitivity is not unlimited, faster film speeds reduce the widest usable aperture on EE. For example, at ASA 400, the maximum aperture indicator moves to $f/4$ at one second. At ASA 800 the indicator shows $f/8$ at one second. Therefore, you may take advantage of lenses at their wider aper-

tures when you use slow speed films, which is when you need wide apertures most.

Protecting the camera meter

If a CdS exposure meter is pointed at a strong light source, such as the sun, for more than a few seconds, it may "go blind," or lose its accuracy for a short period. Avoid pointing the Konica at the sun without a lens cap.

Changing lenses

Depress the lens release button at the front left of the lens mount, grip the middle portion of the lens barrel, turn the lens counterclockwise until the red dot on the lens is opposite the red dot on the camera body, and lift the lens out. To mount a lens, follow the above directions in reverse. Be sure the lens is seated securely and accurately before twisting it clockwise into place. You'll hear the lens release button click when the lens is securely mounted.

Infrared distance index marker

When shooting infrared film with the correct filter, focus the lens as usual. Then move the appropriate distance figure opposite the center red index marker to the right—in line with the red "R" on the lens barrel. This is the infrared compensation mark, since infrared rays come to a different focus from the visible spectrum of light.

Focal plane mark

On the top of the Konica near the rewind knob is a small circle with a straight line through it. This indicates the position of the film in the camera, and is called the film plane mark. If you must measure precise distances for closeup photography, this is the mark to use—from the subject to film.

Holding the camera

Most people are right-eyed, and hold the Konica horizontally as seen in Fig. 20. The right hand grips the body firmly and

Fig. II-20. When you hold the Autoreflex in a horizontal position, use the right hand to grip the body firmly and the right index finger to depress the shutter. Use the left hand to focus.

right index finger depresses the shutter release button—gently. Be careful not to jerk the camera, even slightly. Squeeze the release, a practice you will perfect with experience, even when shooting quickly.

In a vertical position there are two ways to hold your Konica. Fig. 21 shows the right hand under the camera with finger on the shutter release, and the left hand focusing. In Fig. 22 the camera has been revolved 180 degrees, the right hand is on top, and the left hand is on the lens barrel. In either vertical position you must move the camera away from your face to advance the film. (In the horizontal position you should be able to turn the film transport lever without moving your eye very far from the finder.)

Fig. II-21. One way to hold the camera for vertical shots is to place the right hand under the camera and use the left hand to focus.

Fig. II-22. Another vertical position is to turn the camera 180 degrees so that the right hand is on the top of the camera and the left hand is on the lens barrel.

Neck straps and cases

The soft leather case that comes with a Konica T or A has a removable front panel. Unless you're only taking a few pictures, this front panel should be unsnapped and not allowed to dangle in your way. Like many professionals, I have a prejudice against camera cases—they are annoying. A fine camera does need protection, but I much prefer to use the neck strap on the camera itself, and dispense with the case entirely. I keep my cameras in a gadget bag, along with extra lenses and film. There are many types of gadget bags on the market. Choose one that fits your taste and equipment. Keep a lens cap on the camera lens when it is in the bag, or when carrying the camera not in use. However, if you feel more comfortable with your Konica in its own case, by all means use it. I must change film too often on a job to bother. Where do you carry the top of the case if you detach it?

Several types of adjustable neck straps are available with positive locking clips that fit through the strap eyelets on each side of the Konica body. With an adjustable strap, you can place the camera against your chest or stomach at a convenient level. When I am working, I hang two Konicas, one above the other. In this way I have two different focal length lenses, and/ or two kinds of film available at the same time.

Camera care

You may know how to fix an automobile engine or service a computer, but only a professional camera repairman is qualified to treat a sick camera. If something goes wrong, keep your miniature screw drivers out of your Konica. If you don't have the training, do-it-yourself camera repair is almost as advisable as do-it-yourself brain surgery.

Preventative maintenance is the best approach to camera malfunction, and here are a few pointers:

1. Don't touch any part of the camera interior when the lens is removed. The mechanism is delicate when confronted with probing fingers or tools held by an amateur. If you want to

carry a camera body without a lens, use a Konica body cap to seal the lens opening, or place the body in a dust-proof container.

2. Keep the inside and outside of the camera clean by using a soft brush, or cloth, to dust metal and glass. A piece of damp facial tissue may also be used on exterior metal and leather.

3. Lens cleaning fluid and tissue may be used sparingly when needed; don't use a handkerchief unless you do so *very* lightly.

4. Keep your Konica, dry, safe from sand, dust, and moisture, and secure from bumps and falls. This advice may sound obvious, but you'd be surprised. . . .

Repair troubleshooting

There are certain places that *any* 35mm camera may develop mechanical problems. My Konicas have shown *none* of the following hangups, but I have had most of them on previous Brand-X cameras. The symptoms are fairly general:

1. Film transport lever won't turn. Don't force it because there is probably dirt or sand in the gears, or a small part may

Fig. II-23. Sand is the enemy of any camera so keep your Konica covered when not in use, and shield it from loose sand when you are shooting. This picture was used to illustrate a children's book about sand. Taken with the Hexanon 80~200mm zoom lens set at 180mm.

be damaged or broken. For this and the next three items, see a camera repairman.

2. Shutter slows down or vignettes. Springs that control shutter speeds may suffer from fatigue, and 1/250 sec. can become half that speed without your knowing it immediately. If you have overexposed slides or negatives that you cannot otherwise explain, see a camera doctor. Vignetting means that the shutter is not traveling at a constant rate, and one edge of a negative or slide is too light or too dark.

3. Iris bounce. Rarely, but possibly, the iris diaphragm within a lens may malfunction and stay open too long, but the lens will seem to be working automatically. It needs a professional overhaul.

4. Dropped camera or lens. Though the Konica T and A are built to withstand normal use, all sorts of things can be jarred loose or broken if a camera is dropped. In such a case, check the finder, shutter, mirror, and EE system, as well as the tightness of the back cover. Better yet, avoid accidents by keeping the camera on a neckstrap.

If a lens is dropped, cemented elements of glass within may become detached, or the iris diaphragm may be damaged. Check the lens visually, but if results seem odd, have it checked.

Scratches on the film

These may be caused by tiny imperfections in the pressure plate that rests against the back of the film. This plate is easily replaceable.

If scratches occur on the emulsion side of film, they are harder to diagnose. Film is *supposed* to ride along two silver tracks on each side of the body opening, without touching any other part of the camera body. Of course, if you load your own film, used cartridges or the film loader may be causing scratches, rather than the camera.

Treat your Konica like a new baby, and it will age gracefully.

Chapter III

Lenses for the Konica

As a switch on Gertrude Stein's rose, a lens is not a lens is not a lens. This means that in order to enjoy the Konica Auto-reflex T or A at their best, using the EE automatic exposure system, you must use one of many Hexanon lenses marked AR. These lenses include the EE setting and its automatic diaphragm-operating mechanism. Hexanon is the trade name given Konica-made lenses, of which there is a large selection from 21mm to 1000mm. In addition, other Hexanon lenses are available with preset (ARP) and manual (ARM) diaphragm settings; these lenses are less expensive than the AR lenses.

An automatic lens is open at full aperture as you view through the finder and focus. As the shutter is fired, the lens diaphragm stops down to precisely the opening indicated on the Konica meter needle—which results in perfect exposure without further effort. Instantly, after stopping down as the shutter fires, an automatic lens diaphragm opens again to full aperture for brightest viewing and focusing. All this takes place, including the movement of the mirror up and down, in about 1/25 sec., which is as fast as you can view and turn the film-advance lever.

A preset lens includes two rings on the barrel, each marked with *f*/stop scales (Fig. 1). The front ring (equipped with click stops) presets the aperture at the *f*/stop that you selected, and the rear ring actually operates the iris diaphragm within the lens. Using the stopped-down metering index mark opposite *f*/1.4 in the finder, you turn the rear aperture ring until the needle indicates correct exposure. Then turn the preset ring to

51

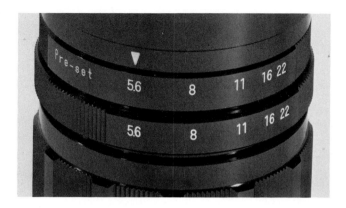

Fig. III-1. The preset lens includes two rings on the lens barrel. The first ring presets the aperture at the f/stop selected, and the rear ring operates the iris diaphragm within the lens.

the same f/stop. Between exposures, you open the lens manually to observe the scene brightly and focus. When you stop down to shoot, the rear ring stops it at the preset aperture, without your having to look at it.

A manual lens is neither automatic nor preset. You stop it down to get the correct meter-indicated exposure, and you open it to full aperture to focus. Before shooting, you must stop it down again visually. Operation is slower than either of the first two lens types. It should be obvious that automatic lenses are much faster, more precise, and more convenient to use, and they remember to close themselves—you may forget to do so with a preset or manual lens.

Lenses other than Hexanons (except for several Vivitars and Tamrons mentioned later) can be used on the Konica by means of adaptor rings. Even if they are automatic on another brand of camera, they must be operated by hand on the Konica, using the stopped-down metering method. Only Hexanon AR, and a few Vivitar and Tamron lenses, are made to operate automatically on the Konica Autoreflex.

HEXANON QUALITY

At least 25 different Hexanon lenses are made for the Konica T and A (seen in Fig. 2, including the 52mm and 57mm lenses on the cameras). Additional focal lengths and types are planned. All Hexanon lenses, regardless of aperture operation,

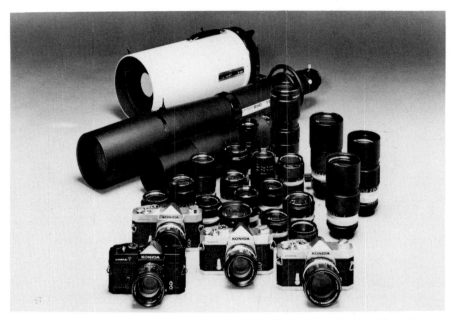

Fig. III-2. There are at least 25 different lenses made for the Konica Autoreflex T and A.

are brilliantly sharp because of their design and the top-notch optical glass developed especially for them. Each lens has what Konica calls a "color dynamic coating," which is a series of multiple layers of coating that eliminates almost all internal "ghost" images, flare, and reflections. Lens coating is especially important when shooting into the light, for a strong light source tends to bounce around within the series of glass elements that make up a lens. Coating helps correct light flare to produce sharper images in any sort of light. If you have ever used a non-coated lens, or one coated some years ago before

better coatings and processes were developed, you realize how much improved today's lenses are.

When you choose a Hexanon lens, one of the few Vivitars, or a Tamron in order to get EE operation, you are assured of top quality in optics and workmanship. Keep in mind you need only buy a specific focal length once. Though preset and manual lenses may be more economical to buy, they cost a lot more in time and effort to use.

If you now own a Konica Autoreflex T or A with a standard lens, and are wondering which focal length to buy next, read on. The following are descriptions of all Hexanon lenses grouped by focal length. Later I'll tackle the myth of the "best" second lens to use.

WIDE-ANGLE LENSES

A wide-angle lens, as its name implies, covers a field of view wider than a standard lens from a given viewpoint. A wide-angle lens is valuable for these reasons:

1. When you are backed up against a wall in a small room, or jammed close to a subject in a crowd, or you cannot back away to get more in the picture than the standard lens covers, the wide-angle is necessary.

2. When you want better-than-average depth of field from very close to the camera to far away, wide-angle lenses are the answer.

3. When you want intentional pictorial distortion that makes foreground objects large and background objects much smaller, choose a wide-angle lens.

4. If you want to emphasize perspective with dramatically converging lines, a wide-angle lens does the job.

There are five Hexanon wide-angle lenses from 21mm to 35mm, and two Vivitar Auto lenses at 21mm and 28mm. Here are details:

21mm Hexanon AR f/4: 90° field of view, 11 elements in 7

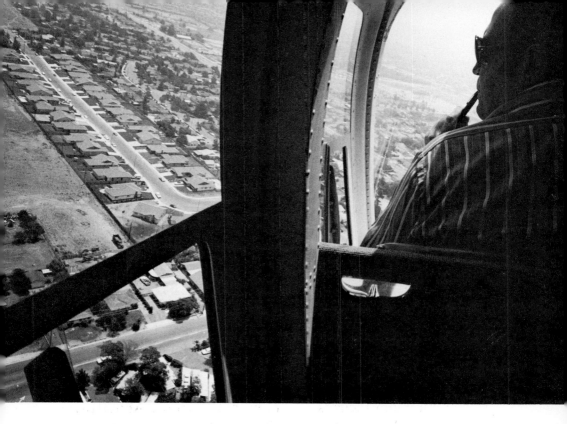

Fig. III-3. Taken with the 21mm Hexanon AR f/4 from a helicopter.

groups; minimum focus is 8 in., weight is 12 oz. A fantastic lens for ultra wide-angle effects and extreme depth of field. Fig. 3 is an example of the 21mm in use in a helicopter. This lens was a natural in such cramped quarters to get my principal subject and the area he was surveying from the air both in sharp focus.

Unlike some SLR camera systems, the 21mm Hexanon works with the Konica mirror in place; some 21mm lenses on other camera brands require locking the mirror up out of the way to accommodate the deep-set lens, which means using an annoying accessory finder.

(Note: *Elements* refers to the number of glass pieces in a lens. *Groups* describes the number of assemblies of elements according to the lens design, which is worked out by a computer for optimum quality at a given price.)

28mm Hexanon AR f/3.5: 75° field of view, 7 elements in 7 groups; minimum focus is 12 in., weight is 7 oz. An excellent

choice if you want a wider scope than the 35mm lens, but don't need the heavier, more expensive ultra-wide 21mm.

35mm Hexanon AR f/2.8: 63° field of view, 6 elements in 5 groups; minimum focus is 12 in., weight is 8-1/3 oz. This is the most popular and generally most useful wide-angle focal length because it is midway between the standard lens and the super-wide 21mm.

35mm Hexanon ARP f/2.0: 63° field of view, 9 elements in 6 groups; minimum focus is 12 in., weight is 11½ oz. Less expensive than the 35mm AR, and much less convenient to use because it is preset.

20mm Vivitar Auto f/3.8: 95° field of view, 9 elements in 7 groups; minimum focus is 6 in., weight is 29 oz. Slightly wider than the Hexanon 21mm, heavier, and somewhat less expensive, this lens offers about the same pictorial potential using the EE system.

28mm Vivitar Auto f/2.5: 74° field of view, 8 elements in 7 groups; minimum focus is 12 in., weight is 16 oz. About twice the weight of the Hexanon AR 28mm, but less money and good quality.

STANDARD LENSES

There is a choice of three standard, or "normal," Hexanon lenses, two focal lengths and three maximum apertures, one of which is usually purchased with the Konica. The one (or more) you prefer will depend on cost, weight, and photographic needs.

52mm Hexanon AR f/1.8: 45° field of view, 6 elements in 5 groups; minimum focus is 18 in., weight is 7½ oz. Probably the most popular standard lens because it costs less and reduces the basic Konica to minimum weight. The aperture is large enough for most average use, and the front element is recessed so no lens hood is necessary.

Fig. 4 was shot with the 52mm Hexanon in the sculpture gardens at UCLA. Since I was brought up on the 50mm lens

as "normal" for the 35mm rangefinder cameras I once used, I find the 52mm a favorite in many situations. Its depth of field is quite enough at smaller apertures, and it is very handy to carry, especially when two cameras hang from my neck together.

57mm Hexanon AR f/1.4: 42° field of view, 6 elements in 5 groups; minimum focus is 18 in., weight is 10 oz. An excellent intermediate fast standard lens offering the advantage of better sharpness at f/2, for instance, than the 52mm f/1.8. No lens is as sharp wide open (at full aperture) as it is stopped down even one stop. The way optical glass is ground and lenses are designed, they produce the best definition when less than the full diameter of the lens is used. Wide open, any lens shows slight to moderate loss of sharpness, depending on its quality and formula. Thus, an f/1.4 lens at f/2 should offer better definition than an f/1.8 lens at f/2. The f/1.4 lens also has nearly an extra stop of sensitivity, which is handy in very low light levels.

Fig. III-4. The sculpture gardens at UCLA; taken with the 52mm Hexanon.

57mm Hexanon AR f/1.2: 42° field of view, 7 elements in 6 groups; minimum focus is 18 in., weight is 17 oz. This is the champion of fast lenses for the Konica. You carry more weight and pay more money, but you are best prepared for dimly-lit scenes. With a slow film such as Kodachrome, you can enjoy the advantages of the EE system on the Konica T at f/1.2, which is about one-half stop more sensitive than the f/1.4, and more than 2¼ times more sensitive than the f/1.8.

MEDIUM TELEPHOTO LENSES

These four Hexanon lenses fall into the medium focal length range. Definitions of "telephoto" are sometimes vague and subjective. Usually, any lens longer than 135mm is considered a telephoto lens.

85mm Hexanon AR f/1.8: 28.5° field of view, 6 elements in 5 groups; minimum focus is 3 ft., weight is 15 oz. This is a fast, useful intermediate focal length to use for portraits and medium-distant scenes. It is faster and shorter in length than the 100mm, but a little heavier and does not "reach out" quite as far.

100mm Hexanon AR f/2.8: 24° field of view, 5 elements in 4 groups; minimum focus is 3 ft., weight is 11 oz. It has less glass, weight, and cost than the 85mm. Excellent for portraits and medium-distant scenics. A favorite of many photographers when traveling because it is less bulky than the 135mm on the camera or in a gadget bag.

135mm Hexanon AR f/3.2: 18° field of view, 5 elements in 4 groups; minimum focus is 3 feet, weight is 12¼ oz. with pull-out lens hood. A very popular near-telephoto focal length for portraits and general scenes. (Notice that longer focal length lenses, except for zooms, require fewer elements; they weigh less, though they extend farther from the camera body.) This new 135mm design has the advantage of being able to focus two feet closer than a former f/3.5 135mm Hexanon, and includes the built-in lens hood. It is illustrated in Fig. 5.

135mm Vivitar Auto f/2.8: 18° field of view, 4 elements in

Fig. III-5. The 135mm Hexanon AR
f/3.2 ens.

4 groups; minimum focus is 4½ ft., weight is 20 oz. Somewhat less money than the Hexanon 135mm AR $f/3.2$. It is also heavier, stops down to $f/22$ ($f/16$ is smallest opening on the Hexanon), is about one-half stop faster, and includes a pull-out lens hood.

TELEPHOTO LENSES

These focal lengths seem to be the "glamor" lenses, perhaps because they are longer in dimension and more impressive. They are most useful for distant scenes that you can't move into, for candid shots without being noticed, and for perspective that appears compressed. Carrying a telephoto means extra weight and bulk, but you can hang one from your shoulder in its own case.

200mm Hexanon AR $f/3.5$: 12° field of view, 5 elements in 4 groups; minimum focus is 4½ ft., weight is 30 oz. Somewhat telephoto compromise, offering a larger image than the 135mm, but less weight, bulk, and cost than the 300mm.

200mm Vivitar Auto $f/3.5$: 12° field of view, 4 elements in 4 groups; minimum focus is 6 ft., weight is 24 oz. Lighter in weight and about one-fourth less money than the Hexanon

Fig. III-6. The 300mm Hexanon AR f/4.5 lens.

200mm AR, this lens has one less element. What this means in terms of sharpness, I'm not certain, but Vivitar optics have a good reputation. A photo magazine rated this lens "excellent."

200mm Hexanon ARP f/3.5: 12° field of view, 5 elements in 5 groups; minimum focus is 8 ft., weight is 30½ oz. About one-fourth less money than the automatic (AR) 200mm Hexanon, but much slower to use because it is preset.

200mm Hexanon ARP f/5.6: 12° field of view, 6 elements in 4 groups; minimum focus is 8 ft., weight is 12 oz. Much lighter with a lower price tag than any of the previous 200mm lenses, this one might be selected primarily on the basis of convenience to carry. Preset and slow.

300mm Hexanon AR f/4.5: 8° field of view, 8 elements in 5 groups; minimum focus is 12 ft., weight is 2 lb. 2 oz. Shown in Fig. 6, this new addition to the Hexanon line offers about six times more magnification of image than the standard 52mm lens and has a retractable lens hood. Few lenses of this focal length are automatic, so this could be a joy for sports and action photographers.

400mm Hexanon ARM f/4.5: 6° field of view, 4 elements in 4 groups; minimum focus is 25 ft., weight is 10 lb. 5 oz. Now we're into the heavy, special-purpose telephotos that are valu-

able for nature and sports photography. Diaphragm is set manually and there is a retractable lens hood.

800mm Hexanon ARM f/8: 3° field of view, 2 elements in 1 group; minimum focus is 70 feet, weight is 12 lb. 6 oz. Includes a folding sight, a filter slot behind the lens, pull-out lens hood, and tripod socket. Almost any lens longer than 300mm requires a tripod. This and the following lens are very specialized. Unless you are going on safari to Africa, or doing long-range spy work, you won't need one to enjoy photography as a hobby.

1000mm Hexanon Reflex ARM f/8: 2.5° field of view, 7 elements in 6 groups; minimum focus is 80 ft., weight is 18 lb. 12 oz. For the price of a decent used car you can have this marvelous, compact mirror-reflex manually operated lens that offers all sorts of possibilities for careful, distance photography.

ZOOM LENSES

"No zoom lens is as sharp at any given focal length as a good single-focal length lens," has been an axiom of photographers—basically, it's true. However, 8″ × 10″ prints or 30″ × 40″ slide projections shot with Hexanon zooms are so sharp that comparisons are odious. Early zoom lens designs (not Hexanons) were not as well formulated as today's models, so sharpness should not worry you if you want a zoom lens. The Hexanons listed below are as sharp as anything on the market— better than many.

Choose a zoom, rather than a series of intermediate focal length lenses, if you want the convenience and pleasure of an infinite number of image sizes in the finder and if you don't mind extra weight and bulk. One camera and two zoom lenses, plus your standard lens, would set you up for a large variety of picture-taking, if your taste runs to zooms.

35~100mm Hexanon Varifocal AR f/2.8: 24° to 64° field of view, 15 elements in 10 groups; minimum focus is 12 in. at

Fig. III-7. The 35~100mm Hexanon Vari-
focal AR f/2.8 lens.

35mm and 39 in. at 100mm; weight is 2 lb. 6 oz. This new lens, seen in Fig. 7, is a *variable focal length* lens, not a zoom. The difference is this: as the focal length is changed, the lens must be refocused. (Once you focus a zoom lens on a given point, it stays in focus throughout its range of focal lengths.) This lens was developed to vary image sizes, but it focuses at much closer distances than a true zoom lens will allow. The Varifocal Hexanon offers the chance to "change lenses" without taking this one off the camera. It can be set for any focal length between 35mm and 100mm, a highly useful range. The lens is fairly expensive, but very practical.

47~100mm Hexanon AR f/3.5: 13 elements in 8 groups; minimum focus is 7 ft., weight is 16 oz. This lens was originally manufactured for half-frame photography with the Konica Auto-Reflex, the first model. It offers a practical range at a reasonable price, but at 47mm it will vignette (shade) the corners of a slide or negative when the lens hood is used.

65~135mm Hexanon AR f/4: 13 elements in 9 groups; minimum focus is 5 ft., weight is 36 oz. This zoom offers an extremely useful range of image sizes.

80~200mm Hexanon AR f/3.5: 12° to 30° field of view, 17 elements in 10 groups; minimum focusing is 6 ft., weight is 2 lb. 8 oz. A neat and convenient range of focal lengths in a

fairly compact mount. The lens operates smoothly, and of course, like all Hexanon zooms, it includes the EE setting for automatic exposure no matter where you point it. Like other Hexanons, it has its own plush-lined case; zoom and telephoto cases include neck straps. Tripod collar revolves with set screw to tighten it, which makes it a cinch to turn the camera from vertical to horizontal.

Fig. 8 is a typical shot with this lens, made at Sea World in San Diego, where Shamu leaps to thrill the audience. Seated in the stands, it was easy to zoom the 80~200mm Hexanon in and out to follow the action and get the image size I wanted without legwork. Exposure was 1/500 sec. at *f*/16 on Tri-X film. Lens was set at full 200mm.

Fig. III-8. Taken at Sea World in San Diego with the 80~200mm Hexanon zoom lens. Exposure was 1/500 sec at *f*/16 on Tri-X, lens was set at 200mm.

CLOSEUP LENS

Macro is a word borrowed from the Greek meaning "large," and in relation to a special lens for closeups, it means to *enlarge*. A macro lens is designed for general use, as well as for closeups without the need for attachments or bellows.

55mm Macro Hexanon AR f/3.5: 43° angle of view, 4 elements in 3 groups; minimum focusing is 1 in., weight is 10 oz. and 14 oz. with adaptor. Using this lens, you can make closeups on EE setting not possible with extension tubes or an accessory bellows. This lens, shown in Fig. 9, includes an adaptor for extreme closeups 1:1 (life size) using the EE setting. The lens

Fig. III-9. The 55mm Macro Hexanon AR f/3.5 lens with adaptor for extreme closeups.

also compensates automatically for the extra exposure necessary at close ranges, a phenomenon known as bellows factor. Several closeups made with the 55mm Macro Hexanon may be found elsewhere in this book.

105 Macro Hexanon AR Bellows has just been announced at the time of this writing and should be at your local dealers now.

TAMRON AUTOMATIC LENSES

In addition to the Hexanons and a few Vivitars, there is another series of lenses recently available called Tamron Adapt-A-

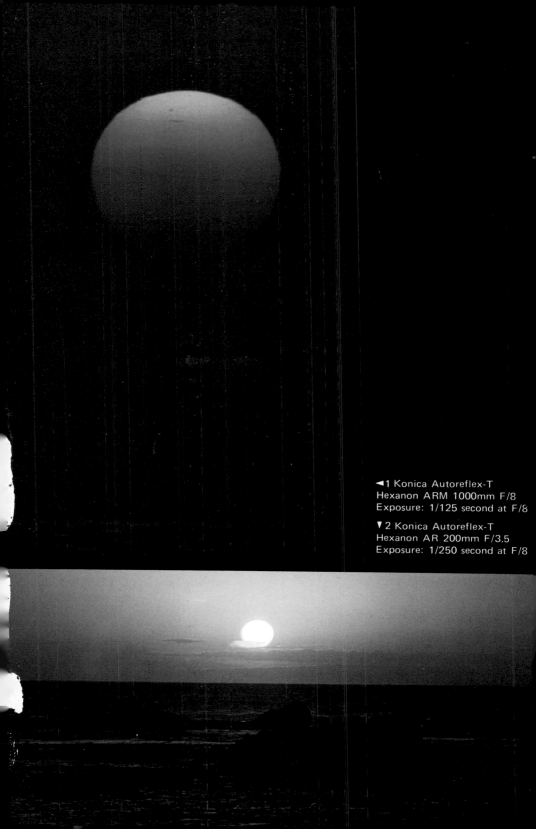

◀1 Konica Autoreflex-T
Hexanon ARM 1000mm F/8
Exposure: 1/125 second at F/8

▼2 Konica Autoreflex-T
Hexanon AR 200mm F/3.5
Exposure: 1/250 second at F/8

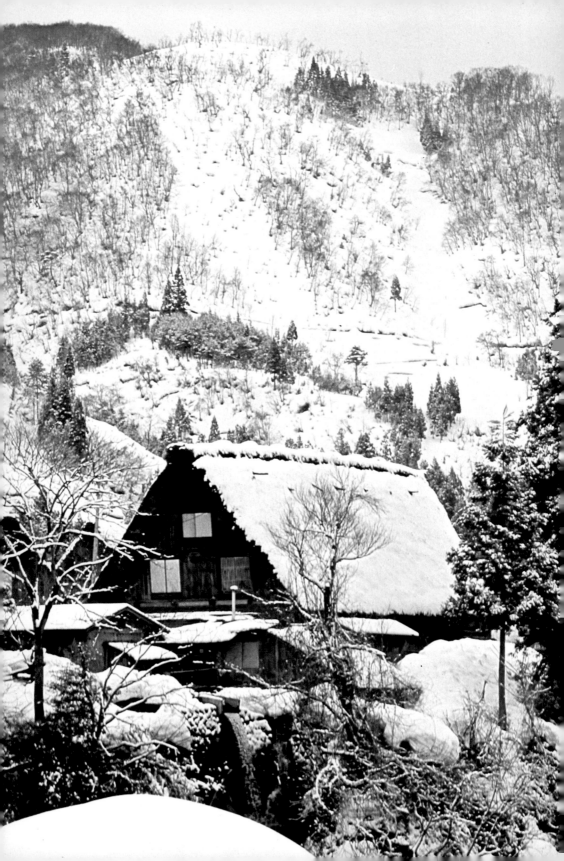

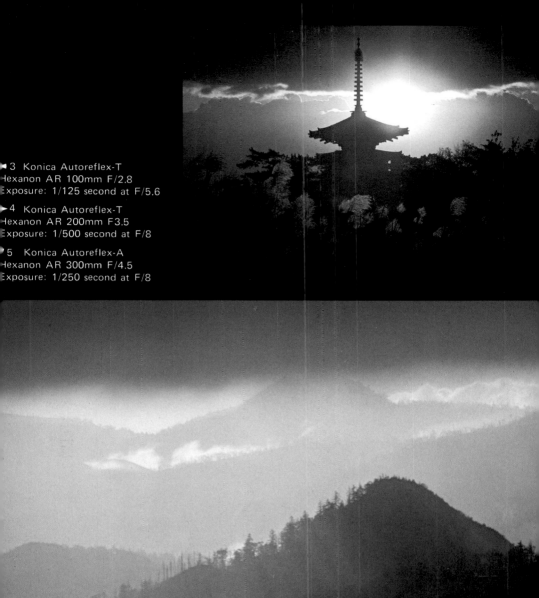

◄3 Konica Autoreflex-T
Hexanon AR 100mm F/2.8
Exposure: 1/125 second at F/5.6

►4 Konica Autoreflex-T
Hexanon AR 200mm F3.5
Exposure: 1/500 second at F/8

►5 Konica Autoreflex-A
Hexanon AR 300mm F/4.5
Exposure: 1/250 second at F/8

7 Konica Autoreflex-T
Hexanon AR 28mm F/3.5
xposure: 1/250 second at F/4

6 Konica Autoreflex
Hexanon AR 35mm F/3.2
xposure: 1/125 second at F/4

8 Konica Autoreflex-T
oom Hexanon AR 80~200mm
xposure: 1/2 second at F/16

9 Konica Autoreflex-T
Hexanon AR 57mm F/1.4
Exposure: 1/125 second at F/5.6
with X-14 Electronic Flash

►10 Konica Autoreflex-T
Zoom Hexanon AR 35~100mm
Exposure: 1/60 second at F/4

▲11 Konica Autoreflex-T
Hexanon AR 85mm F/1.8
Exposure: 1/15 second at F/8

◄12 Konica Autoreflex-A
Zoom Hexanon AR 65~135mm F/4
Exposure: 1/30 second at F/4

▲13 Konica Autoreflex-T
Hexanon AR 21mm F/4
Exposure: 2 minute at F/4

◄14 Konica Autoreflex-T
Hexanon AR 28mm F/3.5
Exposure: 1/125 second at F/16

▼15 Konica Autoreflex-T
Hexanon AR 21mm F/4
Exposure: 1 second at F/5.6

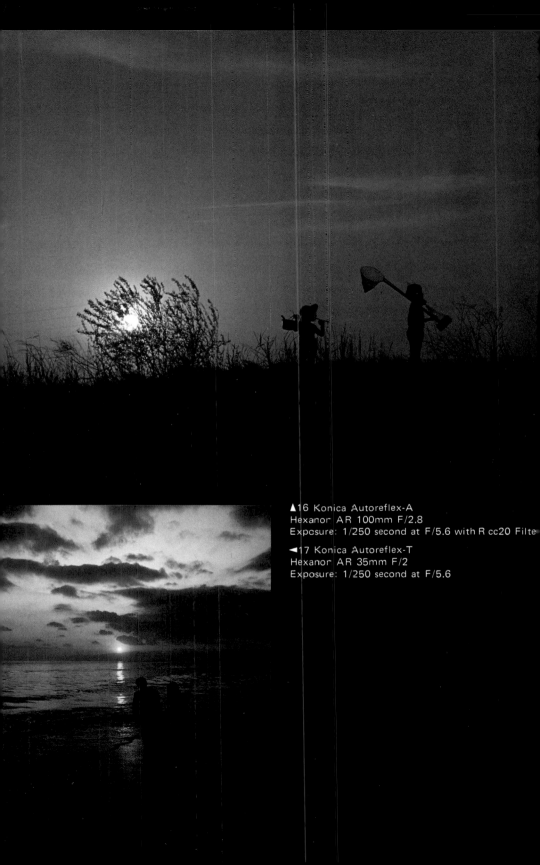

▲16 Konica Autoreflex-A
Hexanor AR 100mm F/2.8
Exposure: 1/250 second at F/5.6 with R cc20 Filte

◄17 Konica Autoreflex-T
Hexanor AR 35mm F/2
Exposure: 1/250 second at F/5.6

▲ 18 Konica Autoreflex-A
Hexanon AR 28mm F/3.5
Exposure: 1/500 second at F/8

◄ 19 Konica Autoreflex-T
Hexanon AR 100mm F/2.8
Exposure: 1/60 second at F/5.6

▼ 20 Konica Autoreflex-T
Hexanon AR 85mm F/1.8
Exposure: 1/125 second at F/8

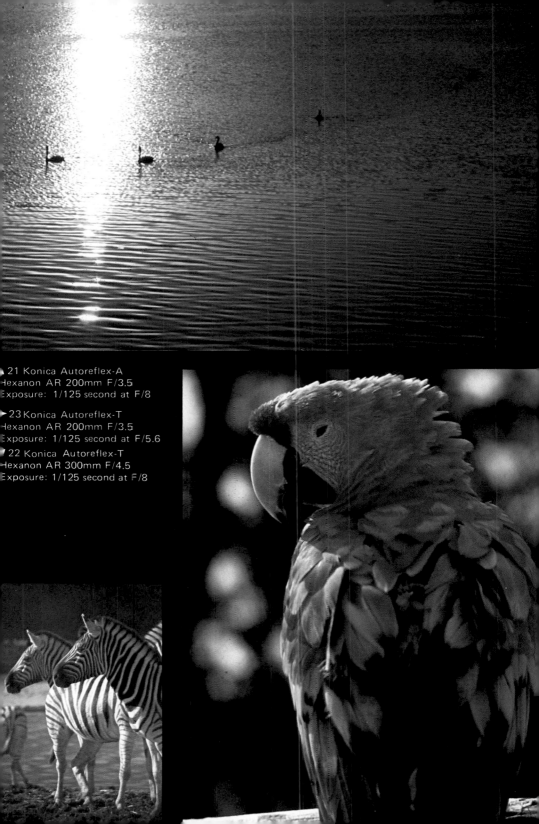

21 Konica Autoreflex-A
Hexanon AR 200mm F/3.5
Exposure: 1/125 second at F/8

23 Konica Autoreflex-T
Hexanon AR 200mm F/3.5
Exposure: 1/125 second at F/5.6

22 Konica Autoreflex-T
Hexanon AR 300mm F/4.5
Exposure: 1/125 second at F/8

◄ 24 Konica Autoreflex-T
Hexanon AR 85mm F/1.8
Exposure: 1/15 second at F/1.8

▼ 25 Konica Autoreflex-T
Hexanon AR 35mm F/2.8
Exposure: 1/250 second at F/8

▼ 26 Konica Autoreflex-T
Hexanon AR 100mm F/2.8
Exposure: 1/125 second at F/8

▲ 28 Konica Autoreflex-T
Hexanon AR 85mm F/1.8
Exposure: 1/60 second at F/8

◄ 27 Konica Autoreflex-T
Macro Hexanon AR 55mm F/3.5
Exposure: 1/4 second at F/16

►30 Konica Autoreflex-T
Macro Bellows Hexanon 105mm F/4
Exposure: 1/30 second at F/8

▼ 29 Konica Autoreflex-T
Hexanon AR 57mm F/1.4
Exposure: 1/250 second at F/5.6 double exposure

▲ 31 Konica Autoreflex-A
Hexanon AR 52mm F/1.8
Exposure: 1/30 second at F/11

►32 Konica Autoreflex-T
Hexanon AR 57mm F/1.4
Exposure: 8 minute at F/5.6

Matic Automatic SLR lenses. Though I have not tested them, the fact that Tamrons are marketed by the same parent company as the Konica cameras and Hexanon lenses would lead me to believe their quality is high. Tamron makes a series of adaptors for various SLR's including the Konica Autoreflex. Each lens has its own adaptor designed according to focal length to synchronize with the Konica metering system. These adaptors list for about $7.00 each.

Tamron's literature states their lenses are made of rare earth glass, and are of high resolution and mechanical dependability. With adaptors, Tamron lenses are priced slightly under Hexanon lenses, except for the 135mm, 200mm, 300mm, and several zooms, which are considerably less. It may be well to check these Tamron lenses while shopping. Listed below are all the focal lengths with the most important information about each for comparison in terms of aperture and weight especially:

21mm f/4.5: Weight is 12 oz., minimum focus is 9 in. Does not require mirror lock-up, and permits the use of economical 17mm screw-in filters *behind* the rear element.

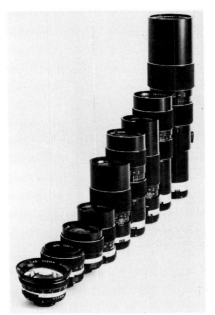

Fig. III-10. Tamron automatic lenses.

28mm f/2.8: Weight is 13 oz., minimum focus is 8½ in.

35mm f/2.8: Weight is 9 oz., minimum focus is 12 in. Recessed front element requires no lens hood.

135mm f/2.8: Weight is 15½ oz., minimum focus is 4 ft. 9 in. Built-in lens hood.

200mm f/3.5: Weight is 1 lb. 12 oz., minimum focus is 6ft. Built-in lens hood, rotating tripod mount.

300mm f/5.6: Weight is 1 lb. 12 oz., minimum focus is 8 ft. Built-in lens hood, rotating tripod mount.

70~220mm f/4 zoom: Weight is 2 lb. 5 oz., minimum focus is 5½ ft. A few ounces lighter and somewhat shorter than the Hexanon 80~200mm zoom, this Tamron has a wider range of focal lengths and costs about one-sixth less.

80~250mm f/3.8 zoom: Weight is 2 lb. 13 oz., minimum focus is 5 ft. 4 in. Slightly less money and slightly heavier than the Hexanon 80~200mm zoom, this Tamron offers 50mm additional focal length.

200~500mm f/6.9 zoom: Weight is 6 lb., minimum focus is 8½ ft. This range of focal lengths has no parallel in the Hexanon series. It is fairly expensive, too heavy to be hand-held, focuses very close for this range, and is designed for the serious photographer.

LENS TESTING

About a dozen years ago, before computers were universally used to aid in lens design, and before glass technology and coating techniques were as well developed as they are now, most new lenses had to be tested when purchased. Today you can almost assume that a fine lens, such as a Hexanon, will be sharp and free of aberrations. Aberrations are optical flaws that create color shifts, lack of definition, or difficulty of focus.

However, if you prefer to test a lens before you add it to your collection, there are lens test kits for sale at camera shops. The process can be tedious, because you must carefully follow the

Fig. III-11. Exposure through the window of a huge tank was once tricky but is now easy with the Autoreflex. Taken with a 52mm Hexanon at 1/125 sec. at f/4.5 on Tri-X rated at ASA 1000.

steps involved, but it may give you more confidence in the beautiful glass bayonet-mounted to your Konica.

There are less complicated ways to test a lens, too. The best of these is just to *take pictures with it*. Test it with the camera on a tripod to eliminate all movement. Focus at various distances, shoot at a series of lens openings, and keep a record of what you do. Then make, or have made, enlargements of black-and-white negatives, or study prints and slides from color. Let your own eyes be the judge.

If you feel that a new lens should be sharper, or that it has a flaw in focus or color rendition, take your results and the lens to your dealer, and ask him to refer the whole case history back to his Konica distributor. Very infrequently, a lens may come through its rigid inspections and still be slightly "off" somehow. Your guarantee will cover this, and you may discover a flaw in your own technique.

Lens sharpness is relative, as you know, unless you have a standard by which to compare. The sharpest sample photograph you have might be your standard. But don't get too involved in lens testing because the optical standards of the Japanese lens-making industry are quite stringent. All of my own Hexanon lenses, bought at random from normal stocks, have been excellent in performance.

THE "BEST" ADDITIONAL LENSES

"Form follows function" is the industrial designer's maxim I learned three decades ago. Translated into making a choice of lenses for the Konica T or A, it means you should decide according to the kinds of pictures you will shoot most often. If you photograph in tight spots and need better-than-normal depth of field, a wide-angle lens might be first on your list.

If you shoot more portraits and landscapes than groups and close-in subjects, an 85mm, 100mm, or 135mm lens may be the next lens you buy. A longer telephoto, such as the 200mm or 300mm, is a must for nature or sports photography.

Zoom or varifocal lenses cover a multitude of situations, and the 35~100mm might be a logical investment to handle many demands from birthday parties to portraits to travel. Certainly, you should weigh the cost and practicality of a zoom before you buy a series of single focal length lenses in the same range. One lens is easier to carry than two or three, and the zoom is quickly convertible.

As you see, there is no "best" second or third lens for everyone. What you buy will be tailored to your needs. However, automatic EE Hexanons are really worth the extra cost over preset lenses, which do not take advantage of the ultra-modern Konica automation.

TECHNICAL DATA

Depth of field is probably the most carefully annotated technical aspect of photographic optics—and perhaps the least

DEPTH-OF-FIELD TABLES

Depth-of-Field Table (57mm f/1.2 · 57mm f/1.4)

Permissible Aberrated Circle Diameter 3/100mm (Unit: Feet)

Distance / Aperture	1.5	1.75	2.0	2.5	3.0	3.5	4.0	5.0	7.0	10.0	15.0	30.0	∞
F 1.2	1.49 / 1.50	1.74 / 1.75	1.99 / 2.00	2.48 / 2.51	2.97 / 3.02	3.46 / 3.53	3.95 / 4.04	4.92 / 5.07	6.84 / 7.16	9.67 / 10.34	14.26 / 15.81	27.14 / 33.54	278.66 / ∞
F 1.4	1.49 / 1.50	1.74 / 1.75	1.98 / 2.01	2.48 / 2.51	2.97 / 3.02	3.45 / 3.54	3.94 / 4.05	4.91 / 5.09	6.81 / 7.19	9.62 / 10.40	14.15 / 15.96	26.71 / 34.21	238.90 / ∞
F 2	1.49 / 1.50	1.73 / 1.76	1.98 / 2.01	2.47 / 2.52	2.95 / 3.04	3.44 / 3.56	3.92 / 4.08	4.87 / 5.13	6.74 / 7.27	9.47 / 10.59	13.81 / 16.41	25.52 / 36.41	167.32 / ∞
F 2.8	1.48 / 1.51	1.73 / 1.76	1.97 / 2.02	2.46 / 2.53	2.94 / 3.06	3.41 / 3.58	3.89 / 4.11	4.82 / 5.18	6.64 / 7.39	9.27 / 10.85	13.39 / 17.05	24.09 / 39.82	119.61 / ∞
F 4	1.48 / 1.51	1.72 / 1.77	1.96 / 2.03	2.44 / 2.55	2.91 / 3.08	3.38 / 3.62	3.84 / 4.16	4.75 / 5.27	6.50 / 7.57	8.99 / 11.26	12.80 / 18.12	22.22 / 46.35	83.82 / ∞
F 5.6	1.47 / 1.52	1.71 / 1.78	1.95 / 2.04	2.42 / 2.58	2.88 / 3.12	3.34 / 3.77	3.78 / 4.23	4.66 / 5.39	6.32 / 7.83	8.65 / 11.87	12.10 / 19.78	20.14 / 59.37	59.97 / ∞
F 8	1.46 / 1.53	1.70 / 1.79	1.93 / 2.06	2.39 / 2.61	2.84 / 3.18	3.27 / 3.85	3.70 / 4.35	4.53 / 5.58	6.08 / 8.26	8.18 / 12.91	11.18 / 22.94	17.67 / 102.87	42.07 / ∞
F 11	1.45 / 1.54	1.68 / 1.81	1.91 / 2.09	2.35 / 2.66	2.78 / 3.25	3.20 / 3.86	3.60 / 4.50	4.37 / 5.84	5.80 / 8.87	7.66 / 14.51	10.22 / 28.70	15.33 / ∞	30.69 / ∞
F 16	1.44 / 1.56	1.66 / 1.84	1.87 / 2.14	2.29 / 2.74	2.69 / 3.38	3.08 / 4.06	3.45 / 4.77	4.14 / 6.34	5.38 / 10.12	6.93 / 18.33	8.94 / 49.67	12.58 / ∞	21.20 / ∞

Depth-of-Field Table (52mm f/1.8)

Permissible Aberrated Circle Diameter 3/100mm (Unit: Feet)

Distance / Aperture	1.5	1.75	2.0	2.5	3.0	3.5	4.0	5.0	7.0	10.0	15.0	30.0	∞
F 1.8	1.49 / 1.50	1.73 / 1.76	1.98 / 2.01	2.46 / 2.53	2.95 / 3.04	3.43 / 3.56	3.91 / 4.09	4.86 / 5.14	6.71 / 7.30	9.41 / 10.66	13.70 / 16.57	25.13 / 37.22	151.88 / ∞
F 2	1.49 / 1.50	1.73 / 1.76	1.98 / 2.01	2.46 / 2.53	2.95 / 3.05	3.42 / 3.57	3.90 / 4.09	4.84 / 5.16	6.69 / 7.33	9.37 / 10.71	13.60 / 16.71	24.81 / 37.97	140.51 / ∞
F 2.8	1.48 / 1.51	1.73 / 1.77	1.97 / 2.02	2.45 / 2.54	2.93 / 3.07	3.40 / 3.60	3.87 / 4.13	4.79 / 5.22	6.58 / 7.47	9.14 / 11.03	13.12 / 17.52	23.21 / 41.50	100.46 / ∞
F 4	1.48 / 1.51	1.72 / 1.77	1.96 / 2.04	2.43 / 2.56	2.90 / 3.10	3.36 / 3.65	3.81 / 4.20	4.70 / 5.33	6.41 / 7.70	8.82 / 11.54	12.45 / 18.88	21.17 / 51.79	70.41 / ∞
F 5.6	1.47 / 1.52	1.71 / 1.79	1.94 / 2.05	2.41 / 2.59	2.86 / 3.15	3.31 / 3.71	3.74 / 4.29	4.60 / 5.48	6.21 / 8.02	8.43 / 12.31	11.67 / 21.07	18.95 / 73.19	50.39 / ∞
F 8	1.46 / 1.53	1.69 / 1.80	1.92 / 2.08	2.37 / 2.64	2.81 / 3.22	3.23 / 3.81	3.65 / 4.42	4.45 / 5.71	5.93 / 8.57	7.90 / 13.69	10.66 / 25.52	16.39 / ∞	35.36 / ∞
F 11	1.45 / 1.55	1.67 / 1.83	1.89 / 2.11	2.33 / 2.70	2.74 / 3.31	3.14 / 3.95	3.53 / 4.61	4.27 / 6.04	5.61 / 9.36	7.33 / 15.92	9.63 / 34.92	14.03 / ∞	25.81 / ∞
F 16	1.42 / 1.58	1.64 / 1.87	1.85 / 2.17	2.26 / 2.80	2.64 / 3.47	3.01 / 4.20	3.36 / 4.97	4.01 / 6.69	5.15 / 11.10	6.55 / 21.93	8.30 / ∞	11.33 / ∞	17.84 / ∞

understood by the beginner. The area in focus between the closest and farthest objects at a given aperture and focusing distance is approximated on each Hexanon lens barrel. In addition, the Konica Autoreflex T has a depth-of-field preview button, which offers a visual approximation of the area in focus.

The third, and most critical, way to understand depth of field for a given lens is the figures in feet and inches of a depth-of-field table. These tables for the 57mm and 52mm normal Hexanon lenses are included below. Study these figures to be more familiar with precise depth-of-field areas. Similar tables for other lens focal lengths may be found in various technical books about photography.

Chapter IV

Exposure Tricks and Treats

When I was growing up in photography, we used to say there was no substitute for good light. The color of the light (daylight or artificial), its intensity, and its direction are the factors that a photographer learns to evaluate visually and mentally to decide if it's "good" light.

Along with the light, there is the subject of your picture to consider. The variety of people, places, and things you can photograph is infinite. So many billions of pictures have been taken in the century-plus since photography was invented that, in most cases, pictures are now variations on themes. However, there is still room for originality in seeing or conceiving pictures. There always will be. The Konica Autoreflex owner has an advantage, for the camera leaves you free to be more creative.

FILMS AND FILM SPEEDS

Before we discuss light and exposure, let's talk about films. There are three types of film from which to choose: black-and-white, positive color for slides, and negative color for prints and/or slides. Each type is manufactured in a number of film speeds rated in ASA (American Standards Association) numbers. These are the same numbers found within the shutter-speed dial of the Konica. Set to the correct film speed, the number guides your built-in CdS meter properly. The ASA number is usually printed on the outside of a film box, but you will easily memorize the speeds of films you usually use.

71

Black-and-white films

The slower the film speed, the finer the grain, and the greater its inherent contrast. This maxim holds true even for color films. Grain is a product of the silver particles that give film its sensitivity to light. The emulsion of a slow film has very fine grain, whereas a fast film has a larger grain pattern to make it more sensitive, i.e., give it more speed. A slow film produces slightly more contrast between highlights and shadows than a fast film, which is slightly "flatter." This means that shadows have a bit more detail and highlights are not quite as bright in a high-contrast sunlight scene for instance. A medium-speed film is somewhere between, a compromise between fast and slow properties.

Choose a slow film, such as Panatomic-X (ASA 32), if you plan to make oversize enlargements beyond 11″ × 14″, and can shoot in light that allows practical shutter speeds and lens open-

Fig. IV-1. Good contrast between highlights and shadows can be obtained with Plus-X film, as shown in this photo of swans on a pond.

ings. A medium speed film, such as Plus-X (ASA 125), yields medium-fine grain, and gives you more latitude in a choice of shutter speed-diaphragm combinations in various light levels. Note the contrast between highlights and shadows in Fig. 1, taken on Plus-X. A careful test would show even higher contrast with Panatomic-X and somewhat less contrast with Tri-X. Outdoors, Plus-X allows you to shoot at a better combination of speeds and openings than Tri-X, which is so fast that you are easily trapped in the $f/16$ and $1/1000$ sec. category.

A fast film such as Tri-X (ASA 400) is suitable in sunlight, but a more obvious choice in weaker light. It does handle sunlight contrast best of all, and its grain pattern should not be noticeable until you make $11'' \times 14''$ prints, or larger. If you wish to avoid using the fastest shutter speed and smallest lens opening on your Konica, try a neutral density filter that will cut the Tri-X speed in half or one-quarter.

Fig. IV-2. A medium or slow color film or black-and-white film allows the use of slow enough shutter speeds to accomplish blur such as this for pictorial effect. Taken with the 135mm Hexanon lens at 1/60 at $f/16$ on Ektachrome-X rated at ASA 64.

Choose a film speed to match the kind of photography you do. Carry several types of film if you expect to need them. You can always rewind a partly exposed roll, leaving the leader stick out of the cartridge, and replace it with another roll, faster or slower, if lighting conditions or subjects change considerably.

Since developers and developing techniques influence film speed and negative quality (which we seek partly according to taste), there is more to be said about black-and-white films than will fit this chapter. AMPHOTO publishes a number of books that delve into vast and helpful detail.

Negative color films

These cover a shorter range of emulsion speeds than black-and-white films, from ASA 64 to ASA 100. Certain negative color films are recommended for daylight and flash, whereas others are for artificial light and longer exposures. You don't have to worry about grain and contrast differences as with black-and-white films. Negative color can be a joy, for from it you can make, or have made, color prints, color slides, or black-and-white prints. Experiment with all three to learn the pros and cons of quality and price.

Color slide films

Among photographers you can always find divergent opinions and preferences about color slide films. The standard by which most comparisons are made is Kodachrome II (ASA 25), also made in a Type A emulsion (ASA 40) for tungsten light. Kodachrome is grainless (because of its unique chemistry), slow, very sharp, slightly more contrasty than faster films, and available everywhere. Whether natural colors appear to be closer to "reality" on Kodachrome can be a matter of taste and opinion. If you don't mind the slow speed, Kodachrome II can be a delight.

Medium-speed films such as Ektachrome-X (ASA 64), Kodachrome-X (ASA 64), and GAF Anscochrome (ASA 64) all offer excellent color and more versatile emulsion speeds. Both

Kodachrome-X and Ektachrome-X offer color quite similar to Kodachrome II, in my opinion, and their added speed often comes in very handy.

There are also fast color slide films such as High Speed Ektachrome (ASA 160 daylight and 125 Type B 3200 K flood bulbs), and GAF Ansochrome 200 and 500 with ASA rating to match their number-names. Use any of these in low-light levels or when fast shutter speeds are necessary for action. You should be familiar with at least one. A roll or two of High Speed Ektachrome along on a trip can pull you through inside a dark cathedral or at dusk when the boat isn't very steady on the lake.

Note: Color negatives are easily made from slides, if you want color or black-and-white prints to show or give away.

A FEW FACTS ABOUT LIGHT

Light may be soft and nearly shadowless, harsh with strongly directional shadows, or somewhere in between. It can be natural daylight, artificial light from man-made sources, or a combination of both. Some light can be controlled, such as floodlights and flash, by where it is placed, and whether it is direct or reflected. In daylight, you may have a choice of effects by planning the time when you shoot, and even waiting until the light suits you. Using artificial light, you have a wealth of variety, and this topic is fully covered in my AMPHOTO book entitled *The ABC's of Lighting*.

Let's categorize types and qualities of light, so we will be speaking the same language when I discuss exposure techniques with the Konica Autoreflex:

Front light is just that; it strikes the subject head-on, and is usually not very exciting. Flash-on-camera is a classic example of front light, which should be avoided unless it's necessary or suits your purpose.

Top light slants from overhead in front of a subject, or from one side. The sun at noon in summer is a typical example, and

it's not very flattering to faces, which show up with dark eye sockets, or to landscapes, which tend to be flat and formless.

Side light creates form-revealing shadows and pictorial drama. It also can create a mood as shown in Fig. 3, which was taken with the 100mm Hexanon lens near a window. No light was reflected into the shadows purposely, to achieve the most in side light contrast.

Fig. IV-3. Side light from a window created a very effective mood in this portrait; taken with the 100mm Hexanon lens.

The best landscapes are often side lighted, and a football team can show up brilliantly against the field with the sun at one side of the players in late afternoon. The low light of early morning from the side is also a delight to dramatize outdoor form.

Backlight. The light source comes from behind the subject and into the camera. In some cases a strong backlight will silhouette a figure or object, but usually backlight offers a very pleasant, sometimes distinguished, pictorial effect. The charming mother and daughter in Fig. 4 did not have to squint into the sun, and their faces are evenly lighted—partly by reflected light from a concrete deck beside a pool. The Konica metering system made all the exposure compensations for me, though backlight, or against-the-light, does offer special exposure problems that are covered more thoroughly below.

Diffused light. Open shade, partly cloudy and overcast skies or reflected daylight or artificial light are all types of diffused light. Portraits are a delight because a model is comfortable and shadows won't distort a face. Landscapes, however, usually look

Fig. IV-4. Backlight was used in this portrait of mother and daughter to create a very pleasant pictorial effect.

too flat, and directional sunlight obviously brings out the form of mountains or buildings more effectively. Professional photographers spend a lot of money to create diffused lighting in their studios, which I simulated in Fig. 7. You can create diffused light in a light-colored room where sunlight, flash, or floods bounce around, and shadows are wiped out. Outdoors in the shade, opposite a reflecting wall or surface, the light will also be pleasantly diffused.

EXPOSURE IN CONVENTIONAL LIGHTING

For the usual front, side, or top lighting, and for most diffused lighting situations, as the Konica instruction book says, point the camera, select an appropriate shutter speed and aperture combination, and shoot. The meter-operated diaphragm gives you ideal negatives or slides. Conventional lighting exposure is usually so easy that even the beginner can feel sorry for photographers with other cameras who must manipulate aperture rings to match a needle before the camera is set. The Konica Autoreflex measures subtleties of light that need not concern you, and automatically translates light intensity to proper exposure with minimum effort. Thus the photographer's main challenges are composition, expression, focus, and timing, all of which make the difference between an ordinary snapshot and exciting images worth savoring. Pictures are far less likely to "get away" while you fiddle with exposure—a necessary task with other quality cameras. The Hexanon EE setting is a labor- and mind-saving device that may require you to find new excuses for unsuccessful prints and slides, because exposure is no longer the scapegoat.

EXPOSURE IN UNUSUAL LIGHTING

The two CdS meter cells within the Konica Autoreflex dome combine their sensitivity in what the manufacturer calls

a "variable metering system." One cell reads a limited "spot" in the center of the finder, while the other averages the light of your complete picture scene. However, these cells operate selectively according to the focal length of the lens. Fig. 5 diagrams the sensitivity distribution for wide-angle, standard, and telephoto lenses. You will note that the center area of the picture being metered is enlarged as lens focal length increases, on the basis that the most important aspect of the scene, in the center, gives the most uniform average of light intensity.

As an experiment, aim your Konica at a scene using a wide-angle lens, and note the lens opening indicated by the finder needle. Now switch to a standard lens, and then to a lens 135mm or longer, zeroing in on the center portion of the same scene each time. Compare aperture readings, and you may be surprised to see they differ because the variable metering system has compensated for changing aspects of the same scene.

28 mm

57 mm

200 mm

Fig. IV-5. Variable metering system.

Backlighting exposure

This is one of two special lighting situations that may "trick" any exposure meter, whether built into the camera or hand-held. When backlight *dominates* a scene, the camera meter sets the aperture to correctly expose for backlight intensity, which causes underexposure for figures, faces, or things in the foreground area. Conversely, when the foreground subject is dominant, as it is in Fig. 4, the meter sets exposure accordingly, and you are assured of excellent shadow detail.

There are two simple ways of handling backlight exposure when you feel that light shining or reflected into the camera is dominant:

1. Temporarily reduce the ASA film speed setting to one-half the normal rating. This will provide an extra stop of exposure,

Fig. IV-6. This is one way to handle backlight exposure when the light shining or reflected is dominant. Exposure was 1/500 sec. at f/11 on Tri-X rated at ASA 200.

which usually compensates for shadow detail without radically overexposing highlights. Fig. 6 was one of a series shot this way. Using Tri-X rated at ASA 400, the exposure read 1/500 sec. at $f/16$. I reset the dial to ASA 200 and shot at 1/500 sec. at $f/11$, hoping as well to throw the background somewhat out of focus with the larger aperture. Had I wanted additional shadow detail, I could have set the film speed at ASA 100 or 150, but I had some reflected light on the model from the deck of the pool. In the negative, the pool is slightly overexposed, but it was burned in while making the print. Had the shot been in color, the blue of the pool would have been a little less saturated, but overall color would have been fine. Remember to reset the film speed correctly when you turn to another lighting situation.

2. When you have only a few backlighted shots to make, you may retain normal film speed and move the camera in close to read the important subject area (such as a face) in shadow. As you hold the camera a foot or less from a face or object, depress the shutter release button part way. This locks the meter needle at the closeup reading. Move back, holding your finger on the shutter release, continue to focus or compose, and shoot. Your exposure will include full shadow detail because the backlight was not measured, and does not influence the selection of lens opening.

Very dark or very light backgrounds

When a light object is seen against a dark background, the meter may read the overall exposure as darker than you wish, and the important light subject will be overexposed. In such a case, take a closeup reading, as described above, or *double* your film speed rating to compensate.

Conversely, in a very bright room or area with white walls, you may get underexposure because the meter is dominated by all the brightness. This is similar to a backlighting situation, and you use the same techniques described before. Fig. 7 is an example of a fashion picture made in a bright room with an off-white background that dominated the scene. I moved the Konica

Fig. IV-7. This fashion shot was made in a bright room with an off-white background that dominated the scene. In a case like this be sure to take a closeup reading of the subject in order to get the proper exposure.

close to the model's face, depressed the shutter release half way, moved back to position, and shot. For a series of similar pictures, I would reduce my film speed rating to avoid moving back and forth.

FILM LATITUDE

Some lighting situations include such a wide difference between the brightest and darkest areas of the picture that you cannot expect ideal results from either black-and-white or color films. High contrast may call for shadow illumination by reflec-

tor, floodlight, or flash. Flash-fill technique is covered in the next chapter.

The ability of film to handle an extreme range of light to dark is called film latitude, and a good measure of it is built into most films. One stop of underexposure or overexposure of a black-and-white film means too little or too much negative density. Skillful printing, however, can produce satisfactory results. Negative color films respond much better to overexposure than underexposure when prints are made. Slide films tolerate half a stop over or under very nicely, but additional error in exposure will result in slides that are too dark or washed out.

Generally speaking, the Konica Autoreflex exposure system rarely strains the limits of a film's latitude. In conventional lighting and with average subjects, the Konica produces beautiful negatives and slides. If your exposures are unsatisfactory, it is usually the fault of photographer error. Errors may include the following: you forgot to use the EE setting, the film speed setting was wrong, meter batteries were weak and failing, or you failed to notice the needle in over- or underexposure red zones at top and bottom of the finder. I've experienced all of these except weak batteries, and can attest that one goof-off is a powerful deterent later.

CAN YOU TRUST A BUILT-IN METER?

After all my discussion of the excellent Konica Autoreflex built-in metering system, this may sound like an odd question. However, it was on my mind the first time I used a match-needle type of 35mm camera quite a few years ago, and it may be on your mind if the Konica Autoreflex is your first experience with the camera-contained metering system.

A professional photographer is often the last to automate his equipment because he labors under the misapprehension that only hand-made, mentally-calculated exposures can really be accurate. In special lighting situations, intuition and experience

Fig. IV-8. An over- or underexposed night shot will sometimes result in a very pleasing picture, depending on the lighting situation. For this shot my Konica meter indicated $f/5.6$ at 1/30 sec. After I made a few exposures at this setting, I opened the 35mm Hexanon lens to $f/4.5$ for more negative density and better contrast.

are obviously an advantage in using any exposure system, but we all meet far more conventional conditions as a rule.

When I first shot with the old-type match-needle SLR, I checked all my exposures with a hand-held meter. Slowly, I learned to trust the camera meter, and was agreeably surprised that results were usually okay. Still, I kept my handy Weston meter nearby on jobs, and used it when I didn't believe the camera meter—which was annoyingly often.

On first using the Konica Autoreflex T, I again checked exposures against my trusty Weston. Not only did I find consistent uniformity, but in some cases, to my amazement, the Konica system was more accurate. This is probably because the

Konica combines both averaging and spot metering, and because the meter is reading precisely what I shoot, while the hand-held meter is pointed only approximately. In summary, I now take for granted that a 36 exposure roll of film will be evenly exposed in my Konicas, providing I use ordinary care setting the dials, and am aware of extreme contrasts in lighting, which may require manipulations mentioned above.

To answer my own question another way, as the final touches were being put on this book, I had a most convincing demonstration that electro-mechanical automation is consistent and reliable. In two days I had to shoot about 1,000 slides for a television production company to demonstrate how their series was going to be changed. Instead of much more expensive motion picture footage, they presented the sponsor a carefully edited slide show. In sunlight, overcast skies, at dusk, and with several quartz floodlights I had to shoot fast and keep three cameras loaded and at work. More than a dozen extras and actors were involved. Had I needed to match-needle the exposures or use a hand-held meter, my production would have been decreased considerably. You may feel that 1,000 shots was excessive, but many situations were very mobile, and I had the actors run through them several times. Film cost was nothing compared with making the sponsor happy and retaining the series another year.

Only a few exposures were off because I didn't compensate for extreme lighting contrast. The Konica metering system literally worked as fast as I could snap, and allowed me to give my client a wide selection of perfectly exposed pictures. It was a pleasure to know that the Konica Autoreflex enabled me to enjoy modern camera design and manufacture on its highest plateau.

Chapter V

Flash with the Konica

Of the many photographic opportunities available to Konica users, making close-ups and using flash are two of the most important. The SLR is ideal for close-up pictures, which are covered fully in the next chapter. Flash photography is the popular expedient when there is too little ambient light, which is another way of saying *existing* light. Indoors or to brighten shadows in sunlight, flash and electronic flash have a place in the photographer's repertoire. Techniques for using the Konica and its accessories for flash are easily learned; too easily, it seems at times, because visual skill in placing and choosing flash can make the difference between an ordinary and an outstanding print or slide.

ELECTRONIC FLASH PHOTOGRAPHY

There are a number of reasons to invest in a small, convenient, transistorized, battery-operated electronic flash unit rather than use flashbulbs or flashcubes. These are well covered in my AMPHOTO book, *Electronic Flash,* and I'll digest them here. Electronic flash offers a compact light source that prevents your carrying a pocketful of cubes. You can amortize the modest cost of a unit in a year or less and you don't have to take time changing bulbs or cubes. The flash is also extremely fast to freeze action.

The smallest electronic flash (EF) units are about the size of two king-size packs of cigarettes, and are powered with inex-

pensive penlight batteries. Most of these units can also be powered on a.c. (house current) with the proper long cord.

Here are a few pointers for choosing a small electronic flash unit:

1. There are many popular brands that will prove reliable. Most are rated at about 40 watt seconds, which indicates the strength of their flash. Medium and fast black-and-white films and fast color films adapt well to this size of EF unit.

2. There is an assortment of batteries to power such units. The standard carbon-type battery costs least and weakens fastest. For a few shots a week, this type (marked for photoflash) is most economical. A set can be replaced in a month or so. Alkaline batteries may be the most practical, however, because they have a longer life than carbon-type, and though more expensive, they will cost less per flash if you shoot fairly consistently.

3. Nickel-cadmium batteries cost most, and last indefinitely because you recharge them every few weeks, even if they have not been used. Depending on how much and how often you use flash, this type may be your best buy. Ask questions at your camera shop and make comparisons

Fig. V-1. Although it doesn't show, a small electronic flash was bounced against a light ceiling when this classroom shot was made for *American Youth Magazine.* The flash helped dilute the harshness of overhead fluorescent lighting. Taken with the 35mm Hexanon at 1/60 sec. at f/8 on Tri-X.

4. High-voltage (250 to 510 volts) batteries are available for some small units (such as the Spiratone Monopak). They are much more expensive than other types, but they last many months. High-voltage batteries require a separate battery pack, which is more weight to carry. When recycling time is a consideration, they can't be matched.

5. Recycling time refers to the interval during which an EF unit builds up power again after being flashed. This interval averages 6–10 seconds when you use carbon-type, alkaline, or nickel-cadmium batteries. A unit will recycle in 1–3 seconds with high-voltage batteries, the choice of most news photographers who cannot wait around while picture situations evaporate. Small units will recycle faster on a.c., incidentally, than on batteries (other than high-voltage). However, most camera fans are not in as much of a hurry as journalists, and 10 seconds between pictures is not a handicap.

6. The price of a small, portable EF unit is not always a true indication of its quality or practicality. Some name brands sell for under $25, whereas others cost more, particularly the automatic-exposure units mentioned later.

Larger electronic flash units

You only need one of these if you shoot slow color film, and more light is a necessity. A number of models are available. They cost and weigh more than the small portables, ranging from 60 to 200 watt seconds. Some include self-contained batteries in a flashlight-type handle beneath the flashing head. Others use separate battery packs hung on shoulder straps. Most larger units have provision for dividing the power in half, which saves the batteries, offers a faster flash, and adapts the light to photographic requirements.

Automatic exposure units

More EF equipment is being automated today. Included in the flash head is a sensor that measures the amount of light needed for a subject according to its reflectivity and distance.

Light output is automatically set to fit the speed of the film, which means you save time and effort, with more consistently good exposures.

Exposure of electronic flash

Though the Konica Autoreflex is admirably designed to measure daylight or artificial light that is steady, it does not operate on the EE setting with flashbulbs, cubes, or electronic flash. (The exception may be flash-fill described below.) You must estimate exposure according to a guide number, or use an f/stop indicated on an exposure dial or chart attached to most EF units. Here are the simple steps for flash exposure:

1. Fit the base of your EF unit into the accessory clip (or shoe) that mounts above the prism dome of the Konica. Plug the synch cord from the flash head into the "X" setting socket in front of the camera, shown in Fig. 2. The "X" is used for electronic flash only. When the shutter is fired, a mechanism within the camera fires the flash at precisely the instant that the shutter is fully open.

2. Set the shutter-speed dial to 1/125 sec. or slower. The chart in Fig. 3 shows that the camera will synchronize for EF

Fig. V-2. Autoreflex flash synchronization terminals.

Con-tact	Shutter speed / Bulb	B	1	2	4	8	15	30	60	125	250	500	1000
M	Class M	o	o	c	o	o	o	o	o	o	o	o	o
	Class FP	o	o	c	o	o	o	o	o	o	o	o	o
	Class MF	o	o	c	o	o	o	o	o	o	o	o	o
X	Strobe	o	o	c	o	o	o	o	o	o	x	x	x

Fig. V-3. Flash synchronization for Konica Autoreflex; o = synchronized, x = not synchronized.

(strobe) at any speed up to and including 1/125 sec. Unless you want some room light to register on the film for a more natural look at speeds such as 1/30 or 1/60 sec., then 1/125 sec. is preferred. Slower shutter speeds can cause "ghost images" when the ambient light is as strong as or stronger than the electronic flash.

3. Focus the camera and note the distance to the subject in feet. If there is an exposure chart or dial on your EF unit, use the f/stop opposite the correct footage and film speed settings. In a darkened room, or outdoors at night, use about one stop more exposure than the dial shows, because there may be no reflecting surfaces to boost the light. For instance, if the dial says $f/11$, use $f/8$.

4. If there is no exposure dial on your unit, or you wish to check its accuracy, refer to the guide numbers usually supplied by the maker of the unit for the type of film you're using. Divide the number of feet from camera to subject into the guide number to get the proper f/stop. For instance:

$$\text{Guide number:} \quad \frac{70}{10} = f/7$$
$$\text{Number of feet:}$$

Again, you must compensate by using a larger opening in dark surroundings, or a smaller opening in a room with white walls and ceiling.

5. Set the diaphragm ring of your lens to the indicated *f*/stop, and shoot. Wind the film, wait for the unit to recycle (a ready-light will come on), and you're ready to shoot again.

Guide numbers are easy to use, and film latitude usually covers small errors in calculation you may make. Obviously, an automatic unit that sets its own light output will save time, and perhaps give you more confidence with electronic flash.

If you use two flash units together, setting one to the side of the subject, you may fire the second one with an electric eye "slave unit" activated by the flash on your camera. Use the flash head closest to the subject to estimate the distance that is divided into the guide number.

Fig. 4 was shot with a small EF unit on the Konica, a Hexanon 35mm lens, and Tri-X film. My guide number is 120, into which I divided the distance to the kids, which was about

Fig. V-4. Shot with a small EF unit on the Autoreflex, a 35mm Hexanon lens, and Tri-X film.

nine feet, indicating an aperture of $f/13$, or midway between $f/11$ and $f/16$. Since the picture was made in a large auditorium with a high ceiling and dark walls, I shot at $f/11$. Electronic flash fires at about $1/1000$ sec., which is ideal to stop action and for candid expressions.

Close flash exposures

When you wish to shoot a portrait, or a subject only three or four feet from the camera, you may find that the $f/$stop indicated by the guide number is smaller than the $f/16$ or $f/22$ of your lens. There are several ways to correct exposure for pleasant lighting at close range.

1. Hold one or two fingers over half the flash head as you shoot, thereby reducing the light to approximately half. Use a lens opening between one and two stops larger than the guide number indicates; take several shots at a series of apertures to be sure.

2. Place a piece of Kleenex or one layer of white handkerchief over the flash head to cut the light about one-half. Experiment ahead of time if possible, so you'll know how much light reduction you're getting. Again, shoot a short series of exposures for safety.

3. Use bounce light described next.

Bounce lighting

Instead of aiming your flash directly at a subject, point it at a ceiling or wall that becomes a reflector from which the light bounces in a fairly soft, even manner that avoids harsh shadows. This is a favorite technique with photo-journalists to achieve a natural look with only one flash source.

To conveniently point the flash upwards, you need a flash extender mount which rotates in any direction, and fits into the accessory clip of your Konica. Rowi makes a neat extender mount for a few dollars.

Bounce exposure has to be "guesstimated," depending on the reflectivity of the ceiling or walls of a room, and the height of

the ceiling. A rule of thumb: calculate exposure as if it were direct flash at a 10-foot distance; divide 10 into the guide number and *open the lens two stops.* You need a larger aperture than for direct flash because the ceiling or wall returns only part of the light to the subject. If the ceiling is white and fairly low, open the lens only one and a half stops. If you are eight feet or more from a group, for instance, tilt the flash head slightly forward to strike the ceiling above the group. Experiment with bounced EF and exposure so you'll have confidence in varying situations.

Fig. 5 was shot with bounced EF while I was about four feet from the smiling man in the center. Direct flash would have been harsh, and probably too close, unless I diffused the light. The ceiling above distributed the light evenly over all three men, and my exposure was 1/125 sec. at *f*/8 using the Hexanon 52mm lens. (Using bounced EF on many magazine assignments, I

Fig. V-5. This photo was taken with the 52mm Hexanon lens and bounced EF. Exposure was 1/125 sec. at *f*/8 on Tri-X rated at ASA 1000.

often rate my Tri-X at ASA 1000 and develop it in Acufine, which gives me an average exposure of 1/125 sec. at $f/8$. With a wide-angle lens, this is a very practical aperture. Rated at ASA 400 normally, the film would require lens openings around $f/4$, which offers uncomfortably little depth of field.)

Bouncing a small EF unit with slow color film may prove difficult or impossible, because you'll be shooting around $f/2$ or $f/2.8$, which means very little depth of field. Use a faster film, such as High Speed Ektachrome, for more practical bounced electronic flash.

Flash-fill

One of the special joys of the Konica Autoreflex is its Copal Square focal plane shutter, which synchronizes at 1/125 sec. for electronic flash. (Most SLR shutters synch at 1/60 sec., making outdoor flash-fill difficult or impossible.) Flash-fill means using your EF unit (or a flashcube or bulb) outdoors to illuminate, or fill, shadows in bright sunlight. Whether the subject is facing the sun, or has his back to it, the EF light gives shadows more detail and better tonal or color balance. Here are the steps for flash-fill:

1. Set the film speed dial correctly, and the shutter-speed dial at 1/125 sec.

2. Use the EE setting. If the needle shows overexposure at 1/125 sec. with the film you're using, switch to a slower film, or use a neutral density filter to cut film speed in half or one-quarter. Neutral density filters, made in 2×, 4×, or 8× ratings, can be used with color or black-and-white films. A 2× filter cuts the light in half, or the film speed in half. A 4× cuts the light or film speed to a quarter, thereby avoiding overexposure. Neutral density filters allow the use of slower shutter speeds with a fast film in bright light, or larger apertures when reduced depth of field would help to throw a background out of focus, for instance. Neutral density filters that screw into the front of a Hexanon lens are relatively inexpensive, and quite handy to improve creative controls.

3. Focus and note the distance to the subject. Using a small EF unit 6 to 12 feet from the subject, the EE setting should work well. If your guide number indicates that the exposure for flash alone would be around $f/11$, and the daylight exposure is $f/16$, the flash-fill balance should be ideal. If necessary, shield part of the flash head with your fingers, or cover it will Kleenex or a handkerchief as mentioned above. Beyond a dozen feet a small unit may have little or no effect.

Figs. 6 and 7 demonstrate flash-fill in use. My Konica was loaded with Panatomic-X (ASA 32), and the exposure for Fig. 6 was 1/125 sec. at about $f/11$. In this backlight the shadows do not reveal much detail, though more than average perhaps, because of reflection from the water. Fig. 7 was shot at the same exposure, and the shadows were filled by my small EF unit (Spiratone Monopak) from about 10 feet, using the 52mm Hexanon lens. This lighting is more pleasant, and especially when shadow detail is important outdoors, the flash-fill technique is quite handy. You may not use it often, but the Konica Auto-reflex makes it possible with ease.

Fig. V-6. Shot with Panatomic-X at 1/125 sec. at $f/11$. Notice that the shadows do not reveal much detail.

Fig. V-7. Shot with the same exposure as Fig. 6, but the shadows were filled by using a small EF unit.

FLASHBULB AND FLASHCUBE PHOTOGRAPHY

There are four main differences between using flashbulbs or flashcubes and using electronic flash:

1. The synchronizer cord from the flash unit is plugged into the "M" socket of the camera for bulbs and cubes (Fig. 2).

2. Bulbs and cubes synchronize at any shutter-speed setting on the Konica as shown on the chart in Fig. 3. With a fast film, you can shoot at 1/500 sec. outdoors for flash-fill, for instance, if EF is not adaptable.

3. Bulbs and cubes must be removed and replaced after each shot, or after four flashes from one cube have been fired. This takes a certain amount of time, but probably not more than waiting for an EF unit to recycle. However, you are distracted from watching your subject. Bulbs or cubes may be more or less expensive than EF, depending on how often you use flash in a year.

4. The duration of light from bulbs and cubes is about 1/50 sec., which, combined with a fast enough shutter speed such as 1/250 sec., will stop most action. Of course, the consistent speed of EF around 1/1000 sec. is certain to "freeze" action under any circumstances, but cubes and bulbs are adequate.

Exposing flashbulbs and flashcubes, using guide numbers printed on cartons, use the same techniques explained for electronic flash. Open the diaphragm a stop or so in darkness, and several stops when bouncing against a ceiling or wall.

Many small folding flashbulb units are available, as well as various units to hold and rotate flashcubes. Konica makes a Cube Flash unit, which has a built-in test circuit with indicator light that shows when a cube can be fired, and it includes an exposure chart and case.

Blue bulbs or cubes, and electronic flash, are all correct for use with daylight color films to make slides or negatives. Clear bulbs (not blue-coated) should be used only for black-and-white films, or tungsten-type color.

Chapter VI

Closeup Photography

Though the unique design of normal Hexanon lenses (52mm and 57mm) allows you to focus to a minimum of 18 inches, there are many occasions when a single-lens reflex and extreme closeup photography are naturally mated. Viewing through the Konica finder, you see precisely the image to be recorded on film (less about a millimeter margin around the edges). This means you can compose closeups very accurately, and more conveniently than upside-down in a view camera, or with image reversed in the finder of a non-prism SLR, such as 2¼" x 2¼" model.

Closeup photography is generally defined as pictures made at magnifications greater than normal lenses permit, which means you need accessories such as rings, bellows, or auxiliary lenses. It is nice to know that Konica makes a complete system of accessories to capture a housefly much larger than life, a postage stamp or coin, or a closeup of the human eye for dramatic effect. Even if you are in the medical arts and use a Konica for fun, there is a microscope adaptor for photomicrography through the microscope lens to view germs or cells through the camera finder. Depending on what you want to shoot, one or more of the neatly designed pieces of equipment described in this chapter will get you closeup while seeing exactly what's in the frame.

Most important, some of these closeup accessories operate with the EE system. If you have ever worked with cameras that required added exposure (according to a chart) as you focused

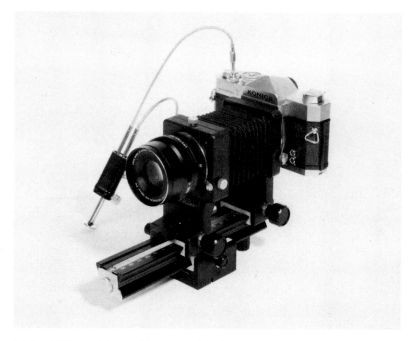

Fig. VI-1. 105mm Macro Hexanon *f*/4 lens attached to the Auto Bellows.

closer to your subject, you'll know how convenient through-the-lens metering can be. No fuss, no calculations, no worries about underexposure. Even if the Konica EE system cannot be coupled to some of this special equipment, the meter in the camera is still making accurate exposure readings that you can set manually, or by the stopped-down technique.

As you may know, or will discover by exploring this chapter, there are two methods for increasing the closeup focusing ability of a normal lens. The first is to add a magnifying or closeup lens to the normal lens, which acts like a magnifying glass but severely limits the minimum and maximum distances at which the lens will focus. Konica makes two attachment lenses for close-ups, which will be described in more detail.

The second method simply requires moving the normal lens closer to the subject, which magnifies the image and allows you to retain sharp focus. Konica makes two bellows accessories, a

set of extension rings, and the 55mm Macro Hexanon AR $f/3.5$ lens for this type of closeup photography. All of these will be covered in this chapter.

NOTE: Konica just announced a 105mm Macro Hexanon Bellows lens as this book went to press (Fig. 1)—see your Konica dealer for details.

SOME CLOSEUP PRINCIPLES

Using closeup lenses screwed into the front of the normal lens or attaching the Macro Hexanon are the two easiest ways of shooting from 18 inches down to about one inch from a subject. In both cases, the camera operates with the EE system, a terrific advantage that makes it simple to turn a slice of orange into an enlarged mystery, perfectly exposed, as in Fig. 2.

When the lens is removed from the camera and used with a bellows or ring set, however, it is important to remember that as it moves farther from the film plane, the distance that the light

Fig. VI-2. This closeup view of a slice of orange was shot with No. 1 and No. 2 attachment lenses on the 52mm Hexanon lens nine inches from the orange.

(or image) must travel from subject to film is lengthened. This increased span cuts down the amount, or intensity, of light that reaches the film. To compensate for light lost, you must increase the f/stop, or decrease the shutter speed, or use a faster film, or increase the amount of light used. Which method you choose will depend on the equipment and instructions that accompany it. Your Konica will help keep such compensations to a minimum.

Even more important, in any closeup photography (attachments, bellows, or even with the Macro Hexanon), depth of field is measured in inches or fractions of an inch. You already understand the optical principle that the closer you focus to something, the shallower depth of field you have at a given aperture. In addition, wider lens openings also yield less depth of field. Thus, the combination of nearness to a subject and wide aperture create such a shallow depth of field that focus is critical. The effect will cause fewer problems if you are photographing a flat surface than if you are homing in on a three-dimensional subject. For this reason, depth-of-field tables are included in the last chapter to inform you of the range of sharpness offered by a normal lens used for closeups. Obviously, the smaller the aperture you can use, the more latitude you will have for tiny errors in focus caused by the limitations of some human eyes!

When you use accessories or attachments to copy or shoot at close range, you must keep the camera steady; this means using a tripod. The slightest camera movement in closeup photography is magnified in enlarged prints or slides to be far more noticeable than when you shoot a medium or distant scene. A cable release to trigger the shutter is also recommended so you do not touch the camera and risk even minimum vibration. Or, the camera's (T model) self-timer may be used to trigger the shutter, too. Closeup photography is stimulating and can open a new visual world for you, if you take appropriate care to assure sharp negatives and transparencies.

Unless you must photograph something tricky such as coins, which require special lighting setups because of reflections, it

Fig. VI-3. Tire tread shot from a few inches away with the 55mm Macro Hexanon lens in daylight; 1/500 sec. at f/16 cn Tri-X.

may be wise to use daylight for your first closeup pictures. Fig. 3 was shot with the 55mm Macro Hexanon lens in sunlight, though it looks as if it was shot in floodlight. The subject is an ordinary automobile tire tread taken from a few inches away, and since the tread was shallow, the camera was hand-held. To assure sharpness I used 1/500 sec. and I focused very carefully; I used an f/16 aperture with Tri-X.

When a subject must be lighted indoors, it is sometimes difficult to set up floods or flash so that texture has the proper highlights and shadows, since tiny variations of a surface are so enlarged. Fig. 4, of bread, is a good example of surface variation. In addition, when you work with closeup equipment, the lens is often so close to the subject that there is rather limited space for lighting. Dentists who photograph the interior of the mouth often use an electronic flashtube shaped in a circle around the lens, which offers even illumination. You should experiment with floodlights set far enough from the camera so that excessive heat will not damage your lens or affect the subject.

One way to make more space between the camera lens and the object you are shooting is to use a 100mm or 135mm lens.

Fig. VI-4. This closeup of a piece of bread is a perfect example of good miniature surface variation.

This increases the lens-to-subject distance, and both accessories and attachments can be adapted to these longer focal lengths. However, the longer the lens, the less its inherent depth of field, so use a normal lens whenever you can to make working close easier and more comfortable.

Closeup photography can be used for many subjects to challenge your photographic skills. Try what has long been called table-top photography: miniature setups of toy soldiers, slotcar or model railroad tracks and equipment, coins, or copies of other photographs. I will describe how I copy color slides in order to make black-and-white prints when I discuss the 55mm Macro Hexanon lens.

CLOSEUP ATTACHMENT LENSES

Starting with the least expensive and easiest equipment to use, Konica makes two auxiliary lenses that screw directly into the front of the Hexanon 52mm $f/1.8$ or 57mm $f/1.4$ normal lenses. Exposure is completely automatic with the EE system.

Lens No. 1 has a focusing range from 25 to 12½ inches. Lens No. 2 works from 14 to 11 inches. In combination, these two lenses allow you to shoot between 12 and 9 inches from a subject.

There are other brands of closeup lenses that screw into your Hexanon lens as well. Some of these come in sets of three to permit photography as close as six inches.

Fig. 2 was shot with No. 1 and No. 2 attachment lenses on a 52mm Hexanon lens at nine inches from the orange to show the amount of enlargement possible with this closeup lens set. (Lens No. 2 should be fitted to the camera first.) The camera was on a tripod and the lens was carefully focused, because my depth of field was probably only one-quarter inch at $f/11$. One floodlight was set low at the left to highlight the texture, which is not very pronounced in a relatively flat object. After setting my lens-to-orange distance and focusing, I moved the light around until the texture and form seemed to show best. Proper illumination, plus the use of small apertures, are two of the constants that help assure effective closeup pictures.

Fig. 2 could have been made with any of the special equipment described below. However, attachment lenses are most portable and offer the advantages of automation if you need not work extremely close to a subject.

EXTENSION RING SET III

The principle advantage of the extension ring set over attachment lenses is the increased proximity of lens-to-subject at which you can shoot. The set consists of three numbered extension rings, 8mm, 16mm, and 24mm in width, plus a lens reversal ring, a camera base ring, and a lens base ring (Fig. 5). You select the rings according to the magnification you desire and the distance you want to be from the subject. The accompanying chart shows the magnifications obtainable with various lens and ring combinations. For photographing flowers, insects, copying, and such, this extension ring set is versatile and easy to use.

MAGNIFICATIONS FOR EXTENSION RING SET III

Combination	0	1	2	3	4	5	6
Rings	CLR*	CLR + 2	CLR + 3	CLR + 4	CLR + 2 + 4	CLR + 3 + 4	CLR + 2 + 3 + 4
Extension (mm)	40	48	56	64	72	80	88
28mm, f/3.5 X Mag.	3.09	3.37	3.66	3.94	4.23	4.51	4.79
35mm, f/2.8 or f/3.5 X Mag.	2.55	2.77	3.00	3.23	3.45	3.67	3.89
52mm, f/1.8 X Mag.	1.26	1.41	1.56	1.71	1.86	2.01	2.16
57mm, f/1.4 X Mag.	1.02	1.16	1.30	1.44	1.58	1.72	1.88

* CLR = Camera Base Ring + Lens Base Ring + Reverse Ring

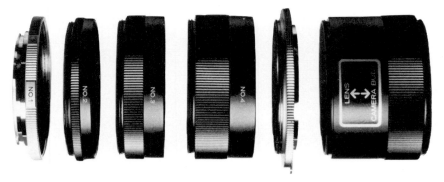

Fig. VI-5. Konica Extension Ring Set III: (left to right) Camera ring, 5mm; Extension ring, 8mm; Extension ring, 16mm; Extension ring, 24mm; Lens ring, 5mm; Reverse ring, 30mm.

Here is the way these closeup rings are mounted:

1. Remove the lens from the camera body.

2. Take the camera base ring, which has a male bayonet mount on one side, and attach it to the camera by matching red dots and turning until it clicks into place, as you would a lens.

3. Screw one or more extension rings into the camera base ring, depending on the desired magnification. You may have to experiment with these rings, mounting the lens as indicated next and viewing to determine if image size is appropriate.

4. Finally, screw the lens base ring with the number "5" engraved next to the red dot into the front extension ring, and mount your lens as you would to the camera body. Red dots will match and lens clicks into place.

Together the three rings will give you a life-size image, or 1:1. For closeups greater than 1:1, best results are obtained by reversing the lens using the following steps:

1. Attach the camera base ring and a choice of extension rings as described above.

2. Screw the lens reversal ring, marked "6," into the front extension ring. Arrows on the reversal ring indicated which side faces the camera.

3. Turn the lens around and screw it front-forward into the reversal ring.

Fig. VI-6. An enlarged section of a leaf. Taken with two extension rings, 1/125 sec. at f/16 on Tri-X.

Exposure with lens reversed, or with lens in conventional position at the end of the extension rings, is by the stopped-down method described in Chapter 2. Lenses are not coupled to the camera body, and therefore do not operate automatically. To review, here are the mechanical steps for setting exposure without the auto ring.

1. View your subject with the lens opened to the widest aperture.

2. Stop down, or close the aperture to the desired f/stop, preferably f/11 to f/16.

3. While looking through the viewfinder, turn the shutter-speed dial until the meter needle in the finder lines up with the small notch opposite "1.4" at top right. If this speed-aperture combination isn't appropriate, adjust both to suit your needs. Pictures will be underexposed when the needle is above the index mark and overexposed if the needle is beneath the mark. When you use the stopped-down metering system, the eyepiece of the finder tends to be affected by extraneous light more readily than when the camera is operating on the EE system at widest aperture. Keep your eye snugly against the finder. Don't be surprised when the needle swings slowly, because that's the way it works.

Even though stopped-down metering is slow compared with EE operation, keep in mind that most closeups are made with painstaking care, and there should be no rush anyway.

Fig 6 was shot using two extension rings with the lens in the conventional position, front-forward. Although it may look like an aerial view of rivers, it's merely an enlarged section of a leaf. I waited for low afternoon sunlight to provide better modeling of the relatively smooth leaf. Exposure on Tri-X was 1/125 sec. at $f/16$. With color film, the addition of color filters might have made this kind of subject even more intriguing.

KONICA AUTO RING AND DOUBLE CABLE RELEASE

I interrupt this essay on closeup photography and equipment to bring you a "commercial" on a most useful accessory that makes possible semi-automatic diaphragm control with the extension ring set and the bellows. This accessory is the Auto Ring and Double Cable Release, as shown in Fig. 7.* One of the twin cables screws into the Auto Ring to operate the dia-

Fig. VI-7. Auto Ring and Double Cable Release: one of the twin cables screws into the Auto Ring and the other cable attaches to the shutter release button.

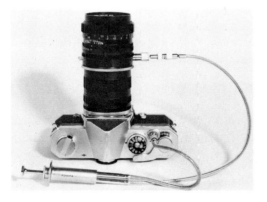

* Earlier versions (with black-finish cable release) had different connections, but operated in the same manner.

phragm, and the other cable attaches to the shutter release button atop the camera. The yellow lever on the ring allows you to use the lens attached to it at full aperture while viewing, and you open the diaphragm after shooting with the same lever. Here's the working system:

1. Mount the Auto Ring (in place of the lens base ring of the extension ring set) by lining up the red dot on the side in which the name "Konica Auto Ring" is engraved with the red dot on the lens.

2. Mount extension tubes (or bellows described later) as noted above, as though to the lens alone, either in normal or reversed position.

3. Screw the short cable of the Double Cable Release to the camera cable release socket, and the long cable to the Auto Ring socket.

Exposure is arrived at by the stopped-down method, except that now you can view and focus with the lens aperture wide open by merely tripping the yellow lever. Once you have selected your f/stop and shutter speed, press the cable release, which closes the aperture to the f/stop selected and triggers the shutter simultaneously. Flip the yellow lever, view, and shoot again.

The ends of both cables include adjustment screw sleeves, and the Double Cable Release has a mobile collar lock that allows you to make time exposures. Of course, this neat piece of equipment is a must if you use rings or bellows and want to enjoy semi-automatic operation of your Konica.

THE 55MM MACRO HEXANON AR f/3.5 LENS

This terrific lens, which includes its own adaptor, was described in Chapter III. It costs a lot more than rings, attachment lenses, or bellows, but it gives you an extremely wide range of closeup distances with full automatic EE operation. With its adaptor you can shoot life-sized images (1:1), and the lens alone can be used for any sort of photography because it focuses at infinity like any normal Hexanon. If you realize when you are

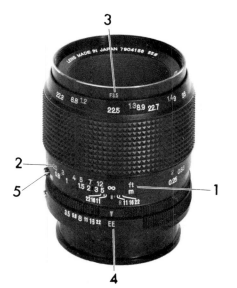
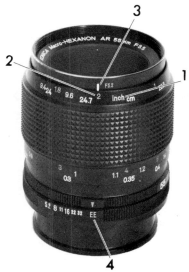

Fig. VI-8A. Scales shown on the 55mm Macro Hexanon lens when adaptor is not attached.

Fig. VI-8B. Scales shown on the 55mm Macro Hexanon lens when the adaptor is attached.

1. Two distance scales in *yellow* and *white* numerals
2. Two magnification scales in *red* numerals

3. Two f/stop compensation scales in *green* numerals
4. Two aperture scales
5. F/stop compensation switch

about to buy a Konica that you will have need for a closeup lens that extends beyond the 18-inch limit, you might arrange to purchase the 55mm Macro *instead* of a 52mm or 57mm Hexanon with the Konica body—if your dealer is willing to accommodate you. Of course, an $f/3.5$ lens has its limits compared with $f/1.8$ or $f/1.4$, but you can add one of these to your equipment at a later date when the need arises.

The Macro Hexanon has two separate sets of scales for distance, magnification, aperture, and $f/$stop compensation. One set (Fig. 8A), is for use with the lens *without the adaptor*. The other set, on the opposite side of the lens (Fig. 8B), comes into view when the lens is used *with the adaptor*. In addition, distance

scales are marked in yellow for feet and inches, and in white for metric measure.

As you may already have noted, there are also two magnification scales marked in red numbers (indicated as No. 2 in Figs. 8A and B). On either side of the lens at the bottom there are two aperture scales (No. 4 in Figs. 8A and B), which compensate for the different apertures required when using or not using the adaptor. Also, along the extending barrel of the lens are two f/stop compensation scales in green numerals, which get higher as the focus gets closer. These numbers represent the changing *effective* maximum aperture of the lens as it is altered by being extended.

Fig. VI-9. F/stop compensation switch.

Examples of the Macro Hexanon in use

Suppose that you are set up to photograph someone's eye, as seen in Fig. 10. When the yellow distance scale (Fig. 8A, No. 1) indicates that the lens is focused at 1.2 feet, for example, the red magnification scale (Fig. 8A, No. 2) shows that the subject is at between one-fourth and one-fifth actual size, shown by the red numbers "4" and "5."

Now *add the adaptor* (Fig. 11), and focus on your subject again. If the yellow distance scale (Fig. 8B, No. 1) indicates the lens is focused at nine inches, the red numeral "1.4" on the magnification scale (Fig. 8B, No. 2) shows that the subject is being photographed close to life-size, or 1:1.4. Actually, you do not have to refer to these scales unless your picture require-

Fig. VI-10. Closeup picture of someone's eye taken by Barbara Jacobs.

Fig. VI-11. Adaptor for the 55mm Macro Hexanon lens.

ments are set to a certain magnification. Otherwise, you aim, frame, and shoot according to your pictorial taste.

Automatic exposure

For EE operation, set the aperture ring to "EE," using the scale shown in either Fig. 8A or Fig. 8B. Move the f/stop compensation switch, as shown in Fig. 9, to the EE setting (which may be marked "O" on some lenses), and the Macro will now work automatically.

A moment ago I mentioned *effective* maximum aperture in relation to very close subject-to-lens distances when the amount of light reaching the film decreases. This can be illustrated first by noting that with the adaptor the f/stop scale at its widest opening is marked f/5.2. Even though the top red indicator in your finder indicates you are using an f/3.5 lens, you cannot shoot anything wider than f/5.2 with the adaptor. Thus, you must compensate for the reduced effective apertures by using the green numerals of the f/stop compensation scale on the lens barrel. The numbers along the white line are for use *with* the adaptor, and the set at the opposite side, *without* the adaptor. This means if the lens is focused close enough with the adaptor so that the green f/6.3 shows on the barrel, do not expose at an f/stop wider than f/6.3 because you will be deluding yourself. Therefore, with the Macro Hexanon lens, those green numbers on the f/stop compensation scale, rather than the top red lens-aperture indicator in the viewfinder, are the true indicators of maximum *effective* aperture. Knowing this, you can change your shutter speed and thus prevent underexposure.

Manual exposure

Should you want to set exposure not using the EE system, with or without the adaptor, move the f/stop compensation switch to "M" (or "X" on some lenses). Then move the aperture ring from "EE" to whatever opening is shown in the viewfinder by the meter needle. Remember, however, that if the needle points to an aperture wider than the green number showing on the f/stop compensation scale on the lens barrel, you should reduce your shutter speed until the meter needle adjusts to a usable aperture again, then set that aperture.

Minimum apertures

Should you wish to shoot at f/22 or f/32 (with the adaptor this is the smallest opening), adjust the shutter speed until the meter needle points to f/16. Now, reduce the shutter speed by one more click (from one-eighth down to one-fourth, for instance) to shoot at f/22, and two clicks (one-eighth down to one-half) to use f/32 with the adaptor. These are easy changes

to make to get maximum depth of field when you are very close to something. In "EE" operation, the apertures will be set automatically; in "manual" mode, you must set them.

Note 1: Remember that light entering the camera *via the viewfinder* can affect meter readings. Therefore, you might use a Konica eyecup or right-angle finder to shield the eyepiece. In the EE mode, after you focus and verify exposure (and don't forget to check the *f*/stop compensation scale), cover the viewfinder gently before releasing the shutter.

Note 2: As an experiment, I mounted the adaptor from my Macro Hexanon to my Konica, and then added the 52mm *f*/1.8 normal lens. Thus extended, the 52mm lens had a limited range of focus, but I could get about four inches from a subject, which would be useful for copying small pictures, for instance.

Note 3: I have often made black-and-white negatives from color slides using the 55mm Macro *with* adaptor on the camera, on a tripod. I simply place the slide on a light box and get in close enough for 1:1 reproduction. Because of variations in slides, I usually make one exposure on EE, and two more, half a stop over and half a stop under, with manual *f*/stop settings. One could shoot color duplicates in the same way, providing the light source was matched to the type of film. Electronic flash is quite useful for duplication, but you must determine exposure by trial and error. Thereafter, it should be uniform with the same film and setup.

KONICA AUTO BELLOWS

For really serious closeup photography, for precision, and for infinite latitude in lens-to-subject distances, the Konica Auto Bellows is a natural. Attachment lenses and extension rings have their focusing limits; the Macro Hexanon is lovely and lightweight, but a bellows is the most sophisticated way to go. Three knobs control critical focusing for continuously variable magnification (see Figs. 12A and B), and both a stand and a slide copier make it even more useful. With the slide copier one can even crop into a slide to reproduce only the desired area. The

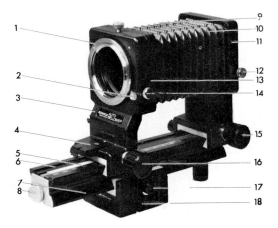

Fig. VI-12A and B. Auto Bellows.

1. Lens mount
2. Lens interchanging button
3. Lens board
4. Slide copier setscrew socket
5. Scale
6. Sliding rail
7. Focusing rail
8. Rail clamp and setscrew
9. Lens front frame set-screw
10. Bellows
11. Camera board
12. Collar-lock screw
13. Intermediate frame
14. Side clamp screw
15. Rear standard adjustment knob
16. Front standard adjustment knob
17. Focusing rail clamp
18. Tripod mount

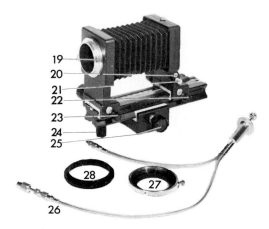

19. Camera mount
20. Cable release setscrew
21. Stopped-down button
22. Lens clamp
23. Camera clamp
24. Rail setscrew
25. Focusing knob
26. Double Cable Release
27. Reverse Adaptor
28. 57mm f/1.2 Bellows Adaptor

Auto Bellows includes a lens diaphragm coupling activated by a depth-of-field preview button or the Double Cable Release.

Mounting the bellows on the camera

 1. Remove the lens from the camera body first.

 2. Make sure the "rotating camera mount" on the Auto Bellows rear standard is at its farthest clockwise position. In

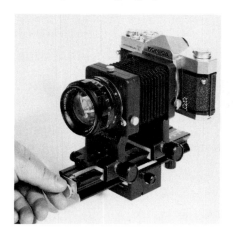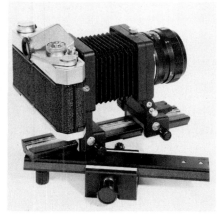

Figs. VI-13 and 14. If you mount the Auto Bellows on a tripod, you can rotate it to a right angle from the focusing rail by loosening the rail clamp (Fig. 13) and the rail setscrew, and turning the assembly (Fig. 14).

Fig. 12B, No. 19 indicates this mount, and the red dot should be at 9 o'clock. It can be rotated by loosening the collar-lock screw, No. 12 in Fig. 12A.

3. Mount the camera to the Auto Bellows by matching red dots and turning the camera clockwise until it clicks into place.

4. Mount the lens to the Auto Bellows in the same way.

5. Connect the Double Cable Release: the long cable into the front standard release of the bellows and the short cable into the camera shutter release button.

6. If the Auto Bellows is mounted on a tripod, you may rotate it to a right angle from the focusing rail by loosening the rail clamp setscrew, then the clamp (as in Fig. 13), and turning the assembly as shown in Fig. 14. If you desire, you may attach the focusing rail to the center of the bellows assembly as shown in Fig. 15. The entire camera/bellows setup can now be moved laterally within a range of 114mm.

Lens reversal

For magnifications greater than 1:1, you will obtain best results by reversing the lens, because this will increase resolution at higher magnifications. One method uses the Konica Reverse Lens Mount Adaptor mentioned previously, and you can get slightly closer this way. Mount the Reverse Lens Mount Adaptor

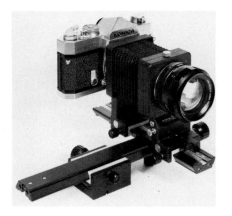

Fig. VI-15. Focusing rail attached to the center of the Auto Bellows assembly.

Fig. VI-16. Reversing the lens with the Reverse Lens Mount Adaptor, the silver ring between the lens and bellows (here the standard Bellows III).

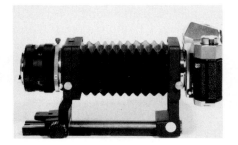

to the front standard of the bellows as though it were a lens, and slide the front of the lens into the face of the adaptor, securing it by tightening the lock screw on top of the adaptor, Fig 16.*

The second way to reverse the lens requires no additional equipment. Using the *front* standard adjustment knob, move the front of the bellows as far forward as possible. Loosen the side clamp screw (Fig. 12A, No. 14), and remove the bellows and intermediate frame from the front standard. With the lens still attached, grasp the front standard firmly, sliding it forward and off the track (Fig. 17*). Turn the front standard and lens assembly around, remounting it on the track with the lens facing the camera body (Fig. 18). Then loosen the front frame set-

* This operation is pictured on the Standard Bellows III, but is identical to use on the Auto Bellows.

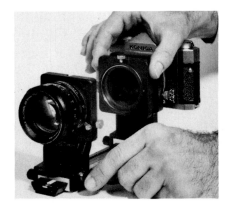
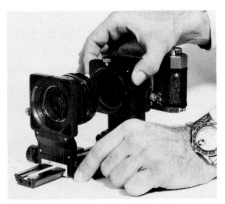

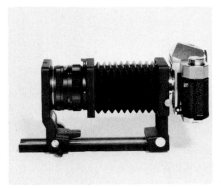

Figs. VI-17-19. Reversing the lens without additional equipment: slide the front standard and lens off the track (Fig. 17) and turn it around, remounting it on the track with the lens facing the camera body (Fig. 18). Then slide the bellows over the front of the lens (Fig. 19).

screw (Fig. 12A, No. 9), and slide the bellows collar over the front of the lens (Fig 19). Secure the lens by tightening the front frame setscrew.

Focusing and magnification

When you have the exact image size required, consult the magnification chart. When you calibrate, always start with the rear standard moved all the way back on the graduated track. After the front standard has been set, focus the entire bellows assembly as a unit by using only the focusing knob shown in Fig. 12B (page 114). This will maintain the correct distance between the two standards. If you are not trying for a specific magnification, you may focus with *any combination* of front and rear standard adjustment knobs *and* the focusing knob.

When focusing the bellows, be sure to use the small locking

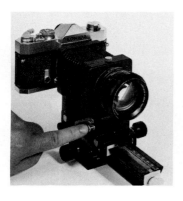

Fig. VI-20. Depth-of-field preview button on front standard of Auto Bellows.

knobs, which should be tightened before shooting when you have exact focus.

Exposure with the Auto Bellows

There are two methods of exposing; the first should be used when the lens is in normal position.

1. After you focus, depress the depth-of-field preview button on the front standard *of the bellows* (Fig. 20), turning it 90° to lock it in place. Instead of this, you may partially depress the Double Cable Release, and lock it into position.

2. Using either the shutter-speed dial or the aperture ring, or both alternately, align the needle in the viewfinder with the index mark opposite the $f/1.4$ setting.

3. Turn the depth-of-field preview button to unlock it, or unlock the Double Cable Release, whichever you are using. The lens will now be at full aperture. Check focus again before shooting.

4. Cock the shutter and depress the Double Cable Release fully. The diaphragm will automatically stop down before the shutter snaps, and then will immediately return to full opening. If you prefer not to use the cable release, leave the depth-of-field preview button locked at the preselected aperture, and shoot via the camera's shutter release button. To avoid vibration, you may use the camera's self-timer, which means the mirror will lock in the up position, eliminating any tiny vibration it may cause.

When the lens is in reversed position, you may operate the camera manually, or semi-automatically with the Auto Ring. In

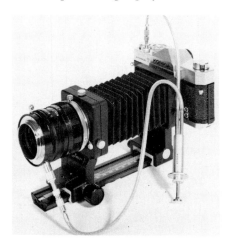

Fig. VI-21. Use the Auto Ring and Double Cable Release for semi-automatic operation when the lens is in reversed position.

the manual mode, adjust the needle to the stopped-down index mark. The diaphragm will remain set at the selected f/stop, rather than return to wide open after shooting. Focus only wide open for accuracy.

Use the Konica Auto Ring and Double Cable Release for semi-automatic operation by mounting the ring on the bayonet side of the lens (Fig. 21), which is now facing forward from the camera, in the manner described previously. You must set exposure manually, but you can now view and focus at full aperture. Partially depressing the Double Cable Release will stop the lens down to your selected opening, and fully depressing it will activate both shutter and diaphragm.

KONICA STANDARD BELLOWS III

This is a less sophisticated version of the Auto Bellows with several significant differences (Figs. 22A and B): There is no focusing rail to move the entire bellows assembly; the rear standard has an ungeared track with locking knob, the front standard has rack-and-pinion focusing; there is no lens diaphragm coupling to permit depth-of-field previewing and semi-automatic exposures—for the latter, the Auto Ring and Double Cable Release are used—and it cannot be used on the Konica Macro Stand.

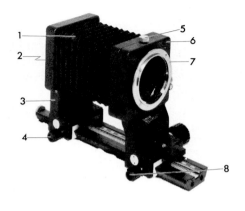

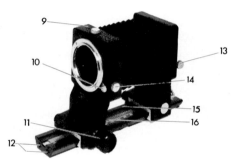

Fig. VI-22A and B. Konica Standard Bellows III.

1. Bellows
2. Camera mount (not visible)
3. Rear standard
4. Locking knob (standard)
5. Top clamp screw
6. Front standard
7. Lens mount
8. Locking knob (front)
9. Intermediate frame
10. Lens release
11. Front standard adjustment knob
12. Slide copier sockets
13. Collar-lock screw for camera mount
14. Slide clamp screw
15. Sliding rail
16. Graduated track

Mounting

1. Remove the lens from the camera body.

2. Make sure the rotating camera mount on the Standard Bellows' rear standard is at its farthest clockwise position (Fig. 22A, No. 2). The red dot belongs at 9 o'clock. Turn the rotating mount by loosening the collar-lock screw (Fig. 22B, No. 13).

3. Mount the camera to the Standard Bellows by matching red dots and clicking into place, a maneuver with which you should be very familar by now!

4. Mount the lens in the same fashion, and focus the assembly for infinity, leaving it in that position.

Note: For greater than 1:1 magnification, reverse the lens by using either the reverse lens adaptor or the following procedure:

1. Using the *front* standard adjustment knob, move the front standard as far forward as possible.

2. Loosen the side clamp screw (Fig. 22B, No. 14), and remove the bellows and intermediate frame from the front standard.

3. With the lens still attached, grasp the front standard firmly and slide it forward and off the track.

4. Turn the front standard and lens assembly around, remounting it on the track with the lens facing the camera body (as for the Auto Bellows).

5. Loosen the top clamp screw (Fig. 22A, No. 5), and slide the bellows collar over the front of the lens (Fig. 18).

6. Secure the lens by tightening the top clamp screw.

Focusing

The method used is the same as that described for the auto bellows. Any combination of front and rear adjustments may be used if no specific magnification is required.

Exposure

Using either the shutter-speed dial or the aperture ring, line up the needle in the camera finder to the index mark opposite the *f*/1.4 setting. Essentially, the technique is the same as that described for the Auto Bellows with the lens in normal or reversed position, *without* the Auto Ring. Use a cable release to avoid camera movement, or use the camera's self-timer.

The handy Konica Auto Ring and Double Cable Release give you semi-automatic diaphragm control with the standard bellows, just as they do with the Auto Bellows. Mounting and operation are the same as described for the latter, except that the Auto Ring is required for semi-automatic use with the lens in standard position.

KONICA SLIDE COPIER II

If you copy slides or convert them to black-and-white negatives very often, my system of using the 55mm Macro Hexanon

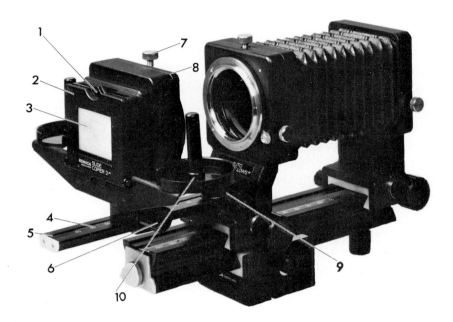

Fig. VI-23. Slide Copier II mounted on Auto Bellows.

1. Slide mount slit
2. Film strip holder
3. Emulsion plate
4. Scale
5. Slide copier rail

6. Slide copier clamp
7. Lens front frame setscrew
8. Lens front frame
9. Slide copier setscrew
10. Roll film tray

is far outweighed by this lovely piece of equipment, which attaches directly to either the Auto Bellows or the Standard Bellows (the former shown in Fig. 23). You can copy mounted or unmounted slides life-size or larger in a rigid rig that offers work-saving features.

The Slide Copier is mounted on a calibrated, friction-drive track, and can be used with the magnification chart for exact pre-selected enlargements. Since one usually works 1:1 or larger with slides, it is recommended that this type of closeup work always be done with the lens reversed for best sharpness.

Mounting

1. Reverse the lens, using the Reverse Lens Mount Adaptor as described for the Auto Bellows. Mount the Slide Copier Reversal Ring to the bayonet mount of the lens.

2. Screw the Slide Copier setscrew into the socket at the base of the bellows front standard (Fig. 23, No. 9).

3. Pull out the front frame of the Slide Copier (Fig. 23, No. 8) and fit it to the rim of the lens, or the 57mm *f*/1.2 adaptor, with that lens. The front frame is easy to pull out since it is held in place by a magnet. Secure frame to lens by tightening front frame setscrew (Fig. 23, No. 7).

Exposure

The same operational techniques described for the bellows apply to using the Slide Copier. The movable slide frame can be shifted horizontally or vertically, allowing portions of a slide to

Fig. VI-24. Konica Macro Stand.

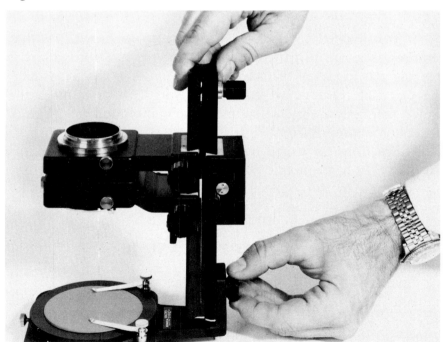

be cropped and magnified. Be sure the slide frame is in the middle position when making full-frame copies.

KONICA MACRO STAND

This special copy stand adapts the Auto Bellows for shooting straight down at small objects or at flat copy such as stamps. The bellows is mounted as shown in Fig. 24, using the stand's mounting screw. The focus knob is not used, but focusing is handled with either front or rear standard adjustment knobs (Fig. 12A). All other steps are the same as those outlined for regular exposure with the Auto Bellows.

Since some objects are so tiny that the Konica meter cannot read them accurately, the clever designers of this stand include a "standard gray" insert, which is 18 per cent gray and supplies the camera meter with an average reading of light intensity.

MICROSCOPE ADAPTOR II AR

If you happen to work in a laboratory, or anywhere that requires shooting pictures through a microscope, this adaptor enables you to attach the Konica to the microscope. This takes the place of the regular lens. Thus, you view directly in the finder, seeing how a specimen under the microscope looks before it is photomicrographed (Figs. 25A and B).

Instructions for mounting the adaptor are included with this accessory; how to mount the camera in place and expose are also covered. With proper lighting, the EE system makes photomicrography a pleasure.

KONICA COPY STAND II

For copying drawings, photographs, or documents with normal lens, Macro Hexanon, attachment lenses, or extension rings, this copy stand neatly positions the camera. Up-and-down adjustments are made by the support column setscrew, and the fine adjustment knob does the rest (Fig. 26). If you don't want to

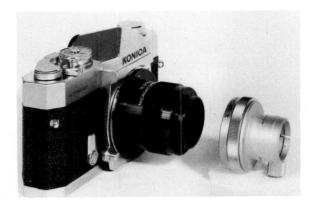

Fig. VI-25A and B. Konica Microscope Adaptor II AR attached to the Autoreflex and mounted on a microscope.

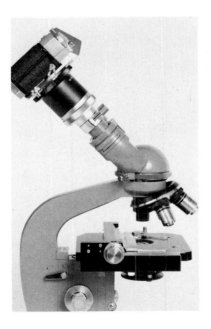

twist your neck above the finder, attach the Konica right-angle finder for easier viewing.

When copying flat material, be sure the lights are set evenly on both sides, and do not reflect from glossy surfaces. Use a lens shade to prevent stray light from entering the lens. The base of the copy stand is painted a neutral 18 per cent gray for expo-

Fig. VI-26. Konica Copy Stand II.

sures when a subject is too tiny to measure alone. If your eye
is not at the finder when you shoot, cover the opening to prevent
extraneous light from altering EE exposures. Use a cable release
to avoid camera movement, or if you have only a few pictures
to copy, use the camera's self-timer.

Certainly, the Konica owner has available a full range of
lenses, rings, stands, and bellows to translate macro into all sorts
of images, from tiny pieces of jewelry to microscopic specimens.
This equipment is made with precision—the same way you
should use it for the most satisfaction.

Chapter VII

Konica Accessories

With one lens on one Konica, and one roll of film, you can enjoy shooting all sorts of pictures. Additional Hexanon lenses, and perhaps several Konica Autoreflex camera bodies will add versatility to the photographic situations you can tackle. Already mentioned as worthwhile accessories are a tripod, a flash or EF unit, and a set of closeup lenses or rings. In addition to these, more Konica accessories are described below. Choose the accessories most important to *you*, first, and then the more specialized equipment as the need arises.

LENS HOODS

No matter what direction you point your Konica in relation to the light source, pictures will be clearer when you use a lens hood (also called a sun shade), which prevents extraneous light rays from reaching the lens. The latest Konica lenses, such as the Hexanon AR 135mm, include a recessed lens hood that slides into place. For all other lenses (except the Hexanon 52mm $f/1.8$ and the 55mm Macro Hexanon, which are set in far enough to need no hood), Konica makes lens hoods to fit. Though some may seem interchangeable because they are the same base diameter, use the hood designed at the correct depth for each specific lens. A lens hood also protects the lens from errant fingers and accidental scratches.

BODY CAP AND REAR LENS CAP

When your Konica Autoreflex is carried or stored without a lens, protect its valuable interior metal and glass with a flat body cap that prevents dust or fingermarks. Each Hexanon lens comes with a rear lens cap, which should stay on the lens when it's carried in a gadget bag or in its individual case. The rear cap covers not only the back lens element, but protects the aperture-setting pin as well.

ACCESSORY CLIP

This clip, shown in Fig. 1, is attached under the removable eyepiece of the Konica, and rests atop the prism dome. The clip is very useful to mount a flash unit on. The Accessory Clip is sold in the United States as standard equipment that comes with your camera.

Fig. VII-1. Accessory Clip.

Fig. VII-2. Angle Finder.

VIEWFINDER CORRECTION LENSES

These specially ground lenses are screwed into the finder eyepiece to correct vision while focusing and composing for near- or farsighted people who wear glasses. With a corrected eyepiece lens, you don't need glasses, and the lenses are available in +1, +2, +3, −1, −2, and −3 diopters. Check with your optician to find the correction you need. A 2× eyepiece magnifier is also available, and clips over the viewfinder eyepiece. It has a hinge so that it can be moved out of the viewing position when not needed.

KONICA CABLE RELEASE

When your camera rests on a tripod or other support, using a cable release to fire the shutter prevents vibration from your hand or fingers, especially at slow shutter speeds.

ANGLE FINDER

Like a small periscope, an angle finder allows you to see through the Konica finder with the camera flat on the floor, high on a tripod, or in some other unusual position. You can also use it for seeing around corners without being seen yourself (Fig. 2).

LENS MOUNT ADAPTORS

Fitted between a lens and the Konica camera body, an adaptor is used for lenses other than Hexanons, such as screw-mount lenses, or bayonet-mount lenses of other brands. Konica makes adaptors for lenses manufactured by Exakta, Pentax, Praktica, and Nikon, as well as for Konica FM, FP, and FS Hexanon lenses. When a lens is attached via an adaptor, the stopped-down metering system is used, since the EE setting is not activated.

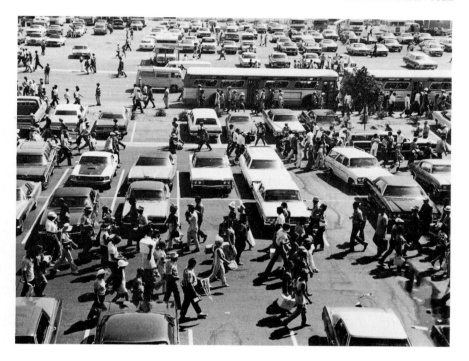

Fig. VII-3. After a day at the races, people form a busy pattern as they make their way to distant cars. A high vantage point offers picture possibilities with various focal-length lenses or zoom lenses. Taken with the 85mm Hexanon.

KONICA FILTERS

Made with the same precision as Hexanon lenses, Konica filters are handy, sometimes necessary, for color correction, and for effects such as darkening skies. Filters screw into the front of lenses. Since exposure is determined by a metering system that measures light coming through the lens, the camera meter compensates automatically for filter density, and no filter factors need concern you. (Filter density is measured in factor numbers by which you multiply exposure time when a camera does not have through-the-lens metering.)

The following chart explains Konica filters and their effects.

KONICA FILTERS AND THEIR USES

Color of Filter	Name	Effect
Colorless*	UV(L39)	Absorbs ultra-violet light at high altitudes or in snow or at the beach, and prevents excess blue. Has some effect in penetrating atmospheric haze.
Light Yellow Yellow Dark Yellow	Y1(Y44) Y2(Y48) Y3(Y52)	All three of these absorb blue, violet, and ultra-violet. For use with B & W films only, especially to darken skies, make clouds stand out.
Orange	O1(O56)	Absorbs more blue than a yellow filter, and darkens skies even more dramatically.
Red	R1(R60)	Absorbs blue and green; blue skies rendered almost black. Used for strong contrast effects in B & W; also used with infrared film.
Yellowish Green	PO 0	Renders greens better than yellow filter with B & W films. Helps prevent washed-out flesh tones when face is against the sky.
Light Gray Gray Dark Gray	ND 2 ND 4 ND 8	ND refers to neutral density filters which do not affect colors with B & W or color films. Used to reduce light intensity and prevent overexposure with fast films. Permits larger lens openings for selective focus and depth-of-field control.
Light Pink*	Skylight	For color or B & W films. Absorbs UV light and prevents excess blue cast in shadows or distant scenes. Particularly useful with Kodachrome.
Light Amber*	A 2	Warms the light in the shadows of snow or beach scenes. Prevents excess blue cast on cloudy days, or in open shade.
Light Blue*	B 2	Cools the color of reddish light of early morning or later afternoon sun. Use only for correction, since reddish cast may be useful effect.
Blue*	B 8	For use with clear (white) flashbulbs and daylight-type color films. Prevents excessive warm tones.
Dark Blue*	B 12	For use with 3200K floodlight bulbs and daylight-type films to correct color.

* Filters most commonly used with color films.

Note: Filters from other manufacturers may be the same or similar colors, but have different names or numeric designations.

Chapter VIII

Composition: The Way We See

To add lasting value to this book, as a manual on effective photography with the Konica Autoreflex, I have included this chapter. There are a number of books about composition—some of them readable. They are directed toward both photographers and artists in other media such as painting or drawing. Basically, the principles of composition are interchangeable, whether you work with brushes or an optical instrument, and you might check other books if knowing more about how we see turns you on.

In my *Random House Dictionary* composition is defined as "the act of combining parts or elements to form a whole." In photography the whole is a picture that we hope to make exciting, or tell a story, or show a scene, or one of many things. Primarily, we try to combine the elements we see through the finder to result in a print or slide that has *impact*.

Impact is the force exerted by a visual idea or concept. It is also the pizzazz or the dynamic influence that a photo has to make viewers want to keep looking because it's beautiful, dramatic, heart rending, subtle, or simply a direct statement that communicates what you saw to others.

Almost anything can be photographed in focus with the correct exposure, and yet turn out to be a dull picture. It may be composed haphazardly, or the subject may be dull. The common name for such a photo is "snapshot," which implies it was taken with minimum care or without awareness. A snapshot merely depicts somebody or something as being there. In many cases,

the same subject might have been handled more effectively. The difference between a snapshot and a good photograph is in *seeing* or *interpreting*.

THE ELEMENTS OF COMPOSITION

I don't like the word "rules" to explain composition because the connotation is too hard and fast, like statutes to control vehicle traffic. I prefer *principles* or *guidelines,* because, although we all see things in a similar way to some extent, within such a framework there is latitude for the influences of individual taste. In other words, we don't all agree on what "good" composition is, or whether a picture is exciting and has impact, and that's what makes occasional contest winners a mystery. Or we look at a picture in print or on exhibition and wonder "Why did they choose *that* one?" However, differences of taste and opinion are healthy; they create competition among photographers, editors, and gallery owners, and provide a wide variety of images to stimulate us—either to admiration or dissent.

Without becoming bogged down in technicalities, let's look at the basic elements that combine to form a whole photograph. Not all of these will be present in every picture because they are not found everywhere in combination. However, these are the structural elements for visual composition.

Lines: You recognize lines all around you: telephone poles, the edges of buildings, converging streets or tracks, and so on. In Fig. 1 the lines of the desks, the blackboard, and the floor, and the edges of the women serve as important components along with forms (figures and rectangles), textures, and space. In this picture, taken at an adult class on women's opportunities in business for an IBM publication, I was not consciously arranging the lines; however, I chose my camera angle (one of many) to catch the horizontal sweep and pattern of the lines interrupted by shapes of the women. (Fig. 1 was shot with a 100mm Hexanon at 1/125 sec. at *f*/6.3 on Tri-X rated at ASA 1000, developed in Acufine.)

Fig. VIII-1. This shot catches the horizontal sweep and pattern of the lines as they are interrupted by the shapes of the women. Taken with a 100mm Hexanon lens at 1/125 sec. at f/6.3 on Tri-X rated at ASA 1000.

Obviously, we don't always see lines, or any of the other ingredients of composition, as isolated features. Exceptions to this statement would be a strong linear fence pattern or thin branches of a bare tree against a winter sky. The edge of a form may also register strongly as a line, such as the ragged edge of a mountain in a landscape.

In traditional theories of composition, a picture is not supposed to be divided in the middle by a line or anything else. If there is a division, such as a horizon, it is classically arranged above or below the center. In addition, if a picture is segmented into approximately equal areas or shapes, there should be a good reason. Otherwise the picture is likely to be monotonous. Essentially, these visual customs make sense. Variety is a prime attraction in a picture, and unequal divisions tend to keep the viewer more deeply interested for a longer period of time.

Exceptions to traditional theories are seen far and wide (Fig. 2, for instance). If "breaking a rule" is effective, it is because a photographer sees something in a new or different way. Lines

are centered or areas are divided atypically to achieve a desired purpose. Look at a Mondrian painting; his lines and forms are the basis for much of modern design and advertising layout. In fact, study the compositions of many well-known painters such as Cezanne, or photographers such as Edward Weston. Edward Weston, who worked with an 8″ x 10″ view camera, accomplished some of the most brilliant and poetic seeing since photography was invented. Although he usually shot static subjects, which he studied carefully as they appeared upside down in his finder, we can all learn some of the fine points of composition by analyzing Weston's photos as published in a number of books.

In contrast, Henri Cartier-Bresson shoots mobile subjects that require quick thinking and visual arranging. His work is also available for study in books, as are the pictures of many fine photographers such as Ernst Haas, Paul Strand, W. Eugene Smith, and Art Kane. Study the pictures in magazines, too, and become aware of the best. Look at them critically, and try to decide why they are outstanding.

A majority of pictures published today are made with 35mm cameras, and you have an advantage over even the famous names who are still matching needles or making separate ex-

Fig. VIII-2. Photographer Cam Smith sitting under one of her own prints.

Fig. VIII-3. Bob Takis shot this action-filled photograph off Waikiki beach in Hawaii.

posure calculations. While you think composition, your Konica takes most of the responsibility for proper brilliance and gradation in your negatives and slides.

One more example before we discuss form. Although photographer Bob Takis shot the action in Fig. 3 (off Waikiki Beach in Hawaii) in a planned candid manner, he did have to be aware of timing and the arrangement of figures, outrigger canoe, and surf boards that he saw both as lines and miniature forms. Notice how the curve of waves and people is balanced against the long horizontal line of the canoe. The visual weight of white foam is supported by the dark water opposite and below. While you as a viewer are involved with the activity of the photograph, you also see it as a dynamically composed pattern that pleases the eye. It takes experience to shoot quickly—and well—when a scene is changing rapidly, which is a strong reason for knowing composition thoroughly. (I don't have technical data on this photo, but it was shot for American Airlines.)

Form: This is another term for shapes, natural and man-made, which may appear in all sorts of situations. We may not think of a racing automobile or two lovers on a bench exactly as shapes, but we are still placing them in a composition just as a painter would. Some shapes are more attractive or dramatic than others, and color or contrast between forms may also add to visual interest. No matter, it is how we see form, including patterns, that amplifies our ability to shoot outstanding pictures.

Using Fig. 4 as an example, the forms and shapes of Far Eastern musical instruments are pretty far out, but photographers delight in exotic subject matter, as well as in finding new ways to see the usual. I walked around this UCLA classroom with

Fig. VIII-4. Far Eastern music class at UCLA. Taken with the 28mm Hexanon at 1/60 sec. between f/5.6 and f/6.3.

Fig. VIII-5. Contact sheet from which Fig. 4 was enlarged.

a 28mm Hexanon on my Konica and took 12 shots in about
five minutes, all at 1/60 sec. between $f/5.6$ and $f/6.3$. One was
vertical, the others horizontal. Fig. 5 shows the 12 exposures
I made of which frame number 27 was enlarged. Why did I
choose number *27*?

Fig. 4 seemed to embody the most interesting forms as a
pattern, and also showed the involvement of the students. Frame
number 23 would have been interesting with the backs of stu-
dents at left cropped off. Others had pictorial appeal, and if you
might have chosen another shot to enlarge rather than number
27, your personal taste and judgment could justify it as well.

Since there are as many kinds of forms to photograph as
there are people, places, and things, it is your awareness of de-
sign within the finder that must be developed in order to place
what you want where you think it is most effective.

For another comparison, quite different from the musical
instruments, see Fig. 6, of an office building with foreground
lighting fixtures framing it at the bottom (shot with the 100mm
Hexanon). Both lighting and texture give the picture eye appeal,
but the basic form is not expressed as dramatically as the same
building in Fig. 7. In Fig 7 I moved in closer with the 35mm

Fig. VIII-6. This office build-
ing with foreground light-
ing fixtures framing it at
the bottom was just one of
several shots used to il-
lustrate an annual report.
Taken with the 100mm
Hexanon lens.

Fig. VIII-7. In this shot I moved in closer with the 35mm Hexanon lens to get the convergence of lines that gives the main form its impact.

Hexanon lens to get the convergence of lines that gives the main form its impact.

Architectural photographers usually try to line up the sides of a structure parallel to the edges of the frame. This can be done with the Konica at the proper distance and camera position with a semi-telephoto or telephoto lens. However, my goal was a different interpretation of this building for an annual report that required the unusual.

We are now getting closer to the nitty-gritty. Photographic composition means using basic design concepts for forceful imagery. We have innumerable options as we compose, but some ways of seeing are more exciting and memorable than others.

Texture: Sometimes the primary pattern of a photograph is so dominant that it becomes a textural composition. Examples include rows and rows of empty seats at a stadium, the repetitive lines of a row of house-fronts, or a mass of marching figures filling a frame. In other cases, textures within the pictures are important elements to consider carefully.

Fig. 8 has a variety of textures, and a good deal of its interest is derived from contrasting surfaces as well. The ghostly quality of reflections and forms seen dimly through the window add to the interest; there is an odd sense of space because we are not

Fig. VIII-8. The ghostly quality of reflections and forms seen dimly through the window make this shot interesting. Taken with the 52mm Hexanon at 1/15 sec. at f/3.5.

sure what is a reflection and what is a real object. Color would have added another dimension to the scene, which points up the interrelationship of all elements we are considering. I shot Fig. 8 with a 52mm Hexanon at 1/15 sec. at f/3.5 with my camera braced on a table.

Space: A sense of space is subject to interpretation, but usually the spatial feeling of a photograph is inherent in the eye's movement from foreground to background where objects get smaller, as typified in Fig. 9. These young people were part of an outdoor philosophy class taught by the bearded man at the left. I chose the 28mm Hexanon to be certain that focus would be sharp from the closest figure into the background. With Tri-X at 1/250 sec., an aperture of f/16 did the trick.

It is not difficult to depict space when you have the near and the distant as a subject. It is when space is subtle or implied, as it is in Fig. 8, that extra pleasures come from solving unusual problems. The painter Paul Cezanne was a master of composing space with lines, forms, textures, and color. Study a few of his landscapes. Notice how colors in the foreground are repeated

Fig. VIII-9. There is a strong sense of spatial feeling in this photo as the eye moves from the foreground to the background where objects get smaller. Taken with the 28mm Hexanon at 1/250 sec. at f/16 on Tri-X.

at the top of the picture. The eye moves back from bottom to implied background between patches of color that, like lines used the same way, are called tension points. Cezanne doesn't use perspective in the traditional pictorial sense; he opened a new world of space to artists who followed the techniques of plasticity he pioneered.

Color: While shooting transparencies or color negatives, we work with the four basic elements discussed above, and add a palette of natural and man-made hues to visual consideration. Usually, where color is concerned, photographers "take what's there," and arrange it in the finder for the most pleasing images. The sky is blue, the clouds are white, the field is green, the flowers are a rainbow, or the face of your model is tanned. In addition, we work with colors contrasted against each other: red against green, blue against yellow, and so on. Monochromatic color schemes are more subtle; in a sunset there may be only shades of orange and red. Still, if we are sensitive to color effects, we will be in better control of the composition and make whatever shifts of position or time that seem to improve our pictures.

The use of color filters to give an overall hue to a scene is becoming a popular technique for visual impact. You may not improve the arrangement of elements, but you can give an ordinary composition more zing. I once photographed two youngsters rowing a boat under some overhanging trees. The sun was behind them, but the water and surroundings were dull earth colors. With a yellow–orange filter over the lens, I tinted the water highlights particularly, and enriched the scene without annoying distortion. There was no need to worry about an exposure increase because the Konica metering system measured the light through the filter and set the f/stop perfectly.

Along with the five elements discussed above, there are a number of other considerations that you must be aware of in relation to composition and later when editing your pictures to decide which will be enlarged or projected in a series of slides. All of these fall within the theme of basic design, or they are involved with picture content. Let's examine them one by one.

Fig. VIII-10. (Left) The two girls are the dominant figures in this composition while the other objects fall into random sequence. 80 ∼200mm Hexanon zoom lens at 1/500 sec. at f/16 on Tri-X.

Fig. VIII-11. (Center) Visual flow moves from the little girl's eyes and face to the stove, across her body, then back to her face.

Fig. VIII-12. (Far right) One of a series of shots set up of a mother and daughter. 85mm Hexanon lens at 1/60 sec. at f/4.5.

Dominance and subordinance

The beginning design student learns that forms, lines, textures, and so forth should be arranged so that one feature in an image is dominant and other features fall into a random sequence of subordination. If this sounds like double talk, look at any picture and decide what shape or area you see *first;* it will be largest, brightest, angled for principal attention, or otherwise dominate the format.

In Fig. 10, the two girls are the dominant figures in the composition. Perhaps your eyes move first to their legs, or maybe you see the complete figures at once. Next you are likely to note the subordinate blurred racing car that is the focus of their attention. Finally, there is the man with beer can, the railing, the fence, and other minor textures. The fact that the girls are large in the center gives them dominance; the car and man are off-center and provide balance, which we will talk about shortly. Fig. 10 was shot with the 80∼200mm Hexanon zoom at 1/500 sec. at f/16, on Tri-X.

One does not look through a Konica finder wondering, What will I make dominant in this scene? Instead you give importance to whatever is necessary to tell a story, make a statement, or

symbolize a situation. As you understand composition more thoroughly, you automatically make something dominant with natural confidence, realizing that in this way, and with appropriate subordinate features, you avoid monotony.

Eye flow

Eye flow doesn't mean tears from weeping, but the concept of how the eye is *supposed* to flow into and through a composition, from left to right, top to bottom, or inside out. In truth, not everyone views a picture in the same sequence, but the photographer should realize that there should be a convenient visual path to follow between the edges of a print or slide. Stop now and look at some of the illustrations in this book, or some of your own. Think about where your vision starts and how it moves according to the design of the image, the content and the directions of its lines or forms, and the placement of dominant and subordinate shapes.

Now study Fig. 11 of a charming little girl. Her play has been interrupted by something out of the frame, and your eye goes first to her eyes and face. Perhaps you wonder what distracted her. Visual flow then moves to the little stove, across the child, and back to her face. It's roughly a triangle. Your eye may

move in or out via the bottom left, the knee, or above the child's head where there are *tangents,* that is, lines or forms that touch the edge. Fortunately, the background is dark because it adds nothing to the composition.

If the above analysis seems to annoy you, please consider it simply an academic exercise. Eye flow varies with the viewer, and obviously, if you have a strong pictorial center of interest, whether it's a wrecked car, a sleeping cat, or any other dominant, the eye starts there. If you photograph a huge crowd pattern, vision may flow along straight or zigzag lines between the faces. As you shoot, awareness of eye flow helps you take advantage of subjects or objects that can be angled or positioned to best design the composition you see.

Emotion and expression

If emotion and/or expression are the chief qualities of your photograph, basic composition may not be ideal, yet the print or slide may have unusual impact or attractiveness. For instance, the feeling between mother and child in Fig. 12 is so pleasant that the distracting shapes in the background and the uninteresting form of the woman's arm do not undermine the message.

Fig. 12 was taken with an 85mm Hexanon lens at 1/60 sec. at $f/4.5$ and is one of a short series I set up. By that I mean I asked mother and child to be close and talk, to react to each other. After setting the situation in motion, I shot rapidly before they could become self-conscious.

Emotion and expression, captured by decisive timing, leap from a photograph to entice or fascinate the viewer who is impelled to share, sympathize, or respond with feeling. A baseball pitcher's face registers intensity; the expressions in a rock concert audience show involvement; and the fun a child experiences at the zoo can be captured in his eyes and stance. Emotion and expression are all around us, and the best photographers have a knack of snapping as they see it peak.

Just the opposite is the typical family snapshot. It may be sharp and neatly composed, but its subjects usually just stand

there like statues acting but not reacting. The snapshot is too often approached merely as a *record* of how somebody looked at a particular location. The more sophisticated photographer catches people doing things, talking, enjoying, worrying, or exhibiting some personality response. Then the print or slide is no longer just a record but a slice of life, which the Konica lends itself so well to capturing.

I might add that longer focal length lenses are often desirable for capturing realistic emotions and expressions, because you can stand back and get reasonably large images without people being as aware of you. Of course, in the middle of a crowd at a political rally or baseball game, you may need a wide-angle lens to include enough, but people will be distracted and not conscious that you're snapping. In any case, if you can focus on excitement, fear, wonder, doubt, anger, or elation, your composition will be enhanced by what Cartier-Bresson called the "decisive moment."

Contrasts

Dark against light, large against small, close against far, active contrasted with passive—these are additional pictorial elements that help create commendable compositions. All are common in photojournalism and advertising. Do you remember the Weegee picture of the bejeweled dowager leaving a theater and passing several panhandlers who look even more down and out in relation to the lady's elegance? Have you ever photographed someone in a bright color against a neutral background? These are common contrasts along with the baby's hand resting in a man's palm, the beautiful nude against hard rock, or the wispy waterfall seen through trees or land forms.

When I shot Fig. 13 at Seaworld, I was conscious of differences in size between the girl, the baby gray whale, and the dolphin. The girl's job was to care for the first gray whale in captivity, and the dolphin was the whale's companion when they swam together in deep water. I have other pictures taken from the top edge of a huge tank that had been drained shallow; none

Fig. VIII-13. I chose this photo taken at Sea World to dramatize the differences in sizes between the girl, the baby gray whale, and the dolphin. Taken with the 85mm Hexanon at 1/250 sec. at f/11 on Tri-X.

of them dramatized the large and small as effectively as this photograph. (I used the 135mm Hexanon to get the right size image from a distance. Exposure on an overcast day was 1/250 sec. at f/11 on Tri-X.)

Emotions can also be contrasted for picture values. A happy kid playing near a bored parent, or an angry policeman chewing out a contrite motorist both typify situations people enjoy seeing on film. Emotion is technically not a technique of composition, but it is an integral part of photography, and the Konica 35mm system offers excellent tools to grab powerful moments.

Backgrounds

Keep them as simple and unobtrusive as possible, but that's old stuff to any experienced photographer who knows what a challenge it is to do so. I continually find myself shifting the camera to one side or another trying to place heads and faces especially against plainer backgrounds. All sorts of junk seem to appear behind people you are photographing. At times it seems impossible to avoid background confusion, so use as large an aperture as possible to throw backgrounds out of focus. Longer lenses (85mm, 100mm, 135mm, and up) with their decreased depth of field are handy for this purpose.

For a change I'm using a dubious example in Fig. 14 to show how a background nearly defeats the action because the figures are difficult to see. The 135mm Hexanon allowed me to move in on the horseplay and eliminate other surroundings, but those geraniums and that bright fence fouled up the picture. If this had been an illustration for a client, I would have found a setting that allowed the kids to play around against a neutral background that did not compete for tonal attention.

Messy backgrounds probably ruin more pictures than any other photographic oversight, except perhaps camera movement and just plain lack of imagination. In the best situations, a background is a meaningful part of the composition, if handled through focus and design as a useful subordinate to a dominant foreground. As examples, the mountains behind a fisherman enhance a scene, or the eager faces of children watching a birthday candle-blowing ceremony support the action. Plain backgrounds are usually indicated for portraits, though businessmen are often carefully integrated into the surroundings of plant or office.

When in doubt, the out-of-focus background may be the best way to control the garbage that often pollutes our pictures.

Cropping and composition

We all try to visualize a picture through the finder at least approximately as it will appear on a print or slide. Everything discussed above is being computed in our minds, consciously and

Fig. VIII-14. This is a perfect example of how a busy background defeats the action because the figures are difficult to see.

unconsciously, as we maneuver the Konica slowly and deliber-
ately, or rapidly when there is action. As soon as we are ready to
make prints (or have them made) or select transparencies to
project, we reach a new stage of pictorial judgment. Rarely is a
full negative printed, and often it seems necessary to mask the
edges of a slide to improve its composition. This is the *cropping*
stage, and it's very important.

Not long ago I was asked to help judge a Department of De-
fense photo contest that included about 600 prints and trans-
parencies from the Army, Navy, Air Force, Marines, and Coast
Guard. Some excellent pictures were awarded medals, but this is
the point I want to make: many of the shots were not sensitively
cropped. There was too much extraneous material left around
the edges of compositions that would have been far improved by
trimming or masking. I couldn't alter those contest pictures, but
you can selectively crop your own photographs. Judge them
critically, and get rid of anything that seems distracting and does
not help tell the story or make the statement you had in mind.

While shooting the next four pictures for this chapter, I went
through a simple exercise. At my local library I asked one of my
sons to talk with a young librarian shown in Fig. 15, which is the
whole negative. (All these shots were made with the Konica
Autoreflex T on Tri-X rated normally at ASA 400. Exposures
were at 1/60 sec. at $f/4$ to $f/5.6$ depending on the light.)

Though the exchange between girl and youngster is okay in
Fig. 15, the background is too busy. Therefore I cropped in on
the two figures to make Fig. 16. The lady at left is gone, but the
figure above Barry's head is still there and would have to be re-
touched by airbrush if I needed it completely removed. Still, the
interplay between the people is better seen in the cropped
version.

I then moved to the other side of the girl and Barry to shoot
Fig. 17. Books in the background are out of focus and less dis-
tracting than figures would be, but in dead center is a black dia-
mond shape that decreases the picture's value. A meaningless

Fig. VIII-17. Fig. VIII-18.

Fig. VIII-15-18. This series was taken at my local library to illustrate a simple exercise in cropping.

shape or object near the center of any composition should be avoided, even though they do appear accidentally. I didn't notice the black diamond as I was shooting, and it bugged me later.

Since there was no way to correct Fig. 17 by cropping, I chose another negative from the dozen I shot. In Fig. 18 the attention is on the librarian, but her serious conversation with Barry can be inferred. I cropped rather closely in the finder, and eliminated more of the surroundings when I printed. Posters on the wall behind the girl's head are slightly annoying, but the librarian is dominant. Were this part of a series, I would balance it with another picture that was in a lighter vein to contrast with the serious mood here.

If you make your own black-and-white or color prints, you know how valuable cropping can be to improve many compositions. Few of us can visualize as thoroughly as Edward Weston did. He made contact prints from his 8″ x 10″ negatives and never cropped at all!

Color slides can be cropped with masking tape along the edges. Do it carefully so lines are straight. Some tapes may leave a residue when removed, so check your neighborhood camera shop for a recommendation about slide cropping materials.

Choose a few of your own prints or slides and examine them with a sharp view of how their design and content might gain impact with a certain amount of cropping. Once you are aware of seeing precisely in your Konica finder, you will eliminate extraneous surroundings as you shoot, while trying to control backgrounds. Later cropping will be easier and more effective.

A FEW VISUAL NOTES

A few more ingredients are also important to exciting pictures, though they are not directly concerned with creating composition. One of these is *mood,* which is established by facial expressions, posing, depictions of human relationships, and lighting. Mood can make or break a photograph. Dominant mood is shown by the color of a sunset, by anxiety, elation, crisis, or peacefulness, which are integral to a subject. Mood can also be subtle and seemingly subordinate.

Action has been covered briefly in some of the illustrations in this book and in Chapter 4. Trying to follow a moving figure or vehicle takes split-second timing to compose and shoot when peak action seems imminent. An object moving towards the camera or away from it is easier to stop (i.e. expose without blur) than one traveling diagonally or parallel to the film plane. The former gets closer or more distant relatively slowly, while the latter two actions tend to zip across in front of you. In an instant a moving image can cover the width of one frame of film,

and you need 1/500 sec. or 1/1000 sec. to stop such action.

To shoot extremely fast action crossing in front of you, you may also choose a fast shutter speed and pan the camera in the direction the subject is moving. Fix your focus at the proper distance for the action when it reaches the spot you want to shoot. Aim the Konica at the subject as it's approaching and gently swing (or pan) the camera with the action, shooting at your predetermined mark. The background will be refreshingly blurred, but the fast-moving subject is likely to be sharp.

Shooting action means relying on instinct. The better trained your seeing, the more likely you will get outstanding pictures. Often, you may want to have your subject intentionally blurred by using a slower shutter speed. This technique can denote action and create a feeling of speed and movement. When done selectively, blurred action can be a very effective technique.

Balance is considered in terms of color, forms, and space relationships. Conventional composition calls for some sort of pictorial balance to prevent an image from seeming to fall out of the format on one side or the bottom. A portrait or subject may be awkwardly unbalanced if crammed to one edge where it must compete with empty space or other objects. However, these conventions are not written into the Constitution. Unusual balance in composition can often be striking, and may be indicated to dramatize a scene or avoid the commonplace.

Since there are a number of well-balanced photographs in this book, Fig 2 was chosen to illustrate departure from the conventional guidelines. I pictured photographer Cam Smith under one of her own prints at the opening of an exhibition. Conventionally, I might have had her stand in front of the scenic, but instead I deliberately divided the composition just above center. The viewer will generally see her face first, and then her figure, and finally the landscape on the wall. The imbalance caused by the white strip is for effect—to give the portrait some distinction. In similar ways we can shift tones, shapes, colors, or lines to gain the sort of balance that adds style to our photography. (Cam Smith was photographed with a 52mm

Fig. VIII-19. I made this shot to show how two library shelves could frame a scene. Taken with the 52mm Hexanon lens at 1/60 sec. at f/6.3.

Hexanon lens using the light in the gallery. Exposure was 1/125 sec. at ƒ/5.6 on Tri-X.)

Framing is a customary technique when you shoot through something, such as a huge pipe, a geometric grid of objects, or under an overhanging roof. Framing can set off an ordinary subject with a certain drama, just as the frame around a painting can amplify its virtues.

As an example, while I was shooting at the library, I made Fig. 19 to demonstrate how two shelves of books could frame

other library activities. An illustration that says "library" can be shot in many ways and from many angles. This one is tucked between books that are both frame and symbols, which also give the viewer a sense of being there. Though it appears to be a wide-angle shot, I used the 52mm Hexanon lens set at $f/6.3$ and 1/60 sec. Perhaps this may encourage readers who have only the normal (52mm or 57mm) lens with their Konica to experiment with ways of angling and composing to make this focal length more versatile.

Study pictures in magazines or newspapers where framing is used as a device. People or faces in the foreground can also be used to frame action or a scene behind them. Be conscious of depth of field when framing, in order to control focus where you want it, when light and film speed allow various options.

Simplicity, above all, means to keep your compositions as direct and restrained as possible. The most memorable photographs you can recall have a basic simplicity, even if a frenzy of activity, a panorama landscape, or human suffering are dominant. Your seeing should be clear and explicit with a minimum of subordinate distractions.

The portrait of author Ernest Raboff and his wife Adeline (Fig. 20) is natural and straightforward. His face is dominant and her head ties into the composition through the areas of black, plus the fact that she is looking at him. The background is anonymous, and I cropped into his head to bring more attention to his face. A simple portrait is instantly accepted by the viewer, whether you like the faces or their expressions or not. In addition, the feeling of affinity between the two subjects and their apparent rapport with me is uncomplicated. Simplicity is a hard goal to achieve but worth the struggle. (The Raboffs were photographed with a 100mm Hexanon at 1/250 sec. at $f/11$ in daylight.)

Add all the elements together and they help explain composition as the way we translate what we see to film and paper. As we see more lucidly, the result is new delight in our own efforts and in the photographs of others.

Fig. VIII-20. Portrait of author Ernest Raboff and his wife Adeline. Taken with a 100mm Hexanon lens, 1/250 sec. at f/11 in daylight.

Chapter IX

Konica Case History Pictures

There are many ways to see and shoot the endless variety of subject matter we encounter; no one approach is the only "right" way. However, we all learn by example, and the illustrations in previous chapters, plus the case history pictures that follow, are typical of photographic problem solving with the Konica Autoreflex.

Before we get specific, it might be well to review the ingredients that are important to an outstanding photograph:

Composition

The study of basic design is a primary way to learn the pros and cons of composition (see Chapter VIII for a thorough discussion of composition). The application of design principles is always personal; "rules" are tempered by experience. A truly exciting photo will usually appeal to a broad spectrum of viewers, no matter how they learned to compose through the finder. Awareness of effective composition ("good" as a description of composition is so relative) is a big advantage to any camera enthusiast.

Lighting

Lighting can make or break a picture, whether the composition is interesting or not. Lighting shows form, or hides it; lighting evokes mood, or disguises it; lighting can accent the expression of a face, the shape of a sand dune, or the outline of a tiny object. Many forms of daylight are most widely used photographically, but you should be familiar with all forms of

artificial light as well. *Look at the light* as you compose. If changing your camera angle or moving a subject might improve the picture in terms of light, do it. Changes of light are often subtle, but the payoff is a kind of glow in your slides or prints that gives them distinction.

Timing

"Luck is when opportunity meets preparation." That definition aptly describes the precise moment when by instinct or planning, you press the shutter release of your Konica. An exciting peak or section of action is there for only a fraction of a second; even a face changes rapidly. Experience in shooting, and study of your slides and prints to analyze mistakes, is the best key to developing the sense of timing that separates the amateurs from the pros.

Craftsmanship

I'm lumping all remaining ingredients into this category, including proper choice of film or lens, and the time and place you choose to shoot. Craftsmanship also means cleanliness in handling film and equipment, plus developing and/or printing your pictures, if you do. Good craftsmanship means you take pride in your photography, as well as your fine camera(s) and lenses. Even in difficult circumstances, when you are working against the tide, you have patience and you stick to the goal, unsatisfied with "good enough." Craftsmanship may be as personal as insight into people as subjects, and an innate sense of beauty or drama to grace your pictures and/or approach to photography. As I see it, craftsmanship means you care enough to take pains in composition, lighting, and in all the ramifications that you face as a serious photographer.

Read other books, look regularly at photographic magazines, debate picture quality with friends, and be turned on when you enjoy your Konica. With such involvement, you are apt to get the most from your camera and its fine Hexanon lenses. Don't be the classic individual who owns a case full of valuable equip-

ment to show off, but rarely use. Anyone with the money can buy a Konica Autoreflex; only the involved owner can really call himself (or herself) a photographer.

CASE HISTORIES

These pictures are a cross-section of the photo opportunities Konica owners are likely to meet in a week, a month, or a year. Of course, I have omitted some useful picture situations, and here I invite you to shoot them yourself, and send them to me for the next edition of this *Manual.* I mean this as an honest challenge and invitation. Any black-and-white prints from black-and-white or color negatives, or converted from color slides, may be sent to me through the publisher of this book, AM-PHOTO, 915 Broadway, New York, N.Y. 10010. Choose carefully, because that's what I'll have to do. I will contact contributors whose pictures I can use in the next edition, and get your permission. In payment you will receive a credit line and a copy of the second edition.

Be certain that all prints have your name and address on the back. Include this technical data as well: Camera model, lens focal length, type of film, lens opening, and shutter speed (you can approximate this if you don't remember exactly), and any

other information you think is appropriate. I look forward to seeing your pictures. Now down to cases.

Figure 1. There's nothing like a zoom lens to follow action, as you probably know. Two of my sons were racing along a go-cart track that twists and bends, so they appear in backlight, side light, and direct sunlight. I didn't have to worry about changing exposure settings to compensate for changing light and shadow because the Konica Autoreflex did the job for me quite accurately. My 80~200mm Hexanon zoom was set at the full 200mm when I shot this at 1/1000 sec. to freeze the action. Detail in the shadows is quite good in the print, though a small amount may be lost in reproduction. The camera and lens were hand-held easily because of the fast shutter speed.

Figure 2. For portraits, as I have said, a longer-than-normal focal length lens produces a more flattering image, and puts you at a greater distance from the subject, which makes self-conscious people a bit more comfortable. Actress Wendy Wilson posed in front of a white wall outdoors after the sun had set and the light

was softly reflected from clouds and surrounding surfaces. With the 100mm Hexanon lens I could frame just her head, or head and shoulders, without distractions. Exposure was 1/125 sec. at about $f/6.3$, which caused the hair in back of her head to be slightly out of focus. (This helps the eye concentrate on her face.) In printing, I used a double layer of a woman's nylon hose (mounted in a cardboard with a hole in the center) under the lens to partly diffuse the image. Diffusion softens lines and makes girls and older people happier with their portraits, unless your models are honest enough to be proud of the character lines in their faces.

Figure 3. With a flashcube (or bulb) or electronic flash on the camera, you use a guide number to calculate exposure and set the lens opening manually. Shutter speeds from 1/125 sec. or slower will synchronize for electronic flash; any shutter speed is okay with focal plane flashbulbs. Direct flash is usually not very artistic, but can be very functional. The young lady here was experimenting on a trampoline, and my electronic flash caught her mid-air easily. Since it was at night, there is only a small amount of shadow behind her legs.

Figure 4. Bounced flash or electronic flash, as has been mentioned, cover a subject more evenly and pleasantly than direct flash, which becomes weaker (or "falls off") in the background of a scene. The situation here was an encounter group

meeting at night in a private home. Subjects were getting acquainted by touching, and the flash was bounced from a warm-tone wood ceiling, not an ideal surface for reflection. Exposure was 1/125 sec. at f/5.6 with Tri-X rated at ASA 1000. This is a stop more exposure than I use for a white or off-white ceiling. Greater depth of field would have been possible with a more powerful EF unit, or in a brighter room, but the uniform illumination of bounced EF is more pleasant than direct flash.

Figure 5. High contrast lighting conditions are often a cause for concern about exposure, because exposure meters can be "tricked," and film latitude has its limits. Excessive light or dark tones that dominate a scene can result in over- or underexposure. However, in this landscape by Eleanor Bralver, taken with a 52mm Hexanon lens, the two CdS cells within the camera neatly averaged sky, clouds, and dark foreground to produce a balanced negative. There is some detail in the house and in the distant bright horizon, which may be diminished in reproduction. The picture is a graphic demonstration of the Konica's automatic versatility.

Figure 6. Window light, reflected around the walls of a hotel room, beautifully illuminated the face of this Arab sheik from Mecca. I was photographing a portion of his visit to America for the United States Information Agency. While a reporter interviewed him, I sat 10 or 12 feet from the sheik with a 135mm Hexanon lens and snapped a series of candid impressions. Again the Tri-X was rated at ASA 1000, and the exposure was 1/125 at *f*/5.6. I remember watching the exposure meter needle at the right of my Konica finder waver slightly as the sheik turned his face towards the light and away from it. I could concentrate on expression and timing without worrying about adjusting the aperture ring; the camera is designed to capture the subtleties of the changing light intensity. You will become accustomed to beautifully even rolls of negatives and slides produced by the Konica, especially if you had been using a match-needle SLR or a rangefinder 35mm camera.

Figure 7. Through-the-lens metering is a pleasure in this situation when you can't get closer to a subject to use a hand-held meter, if you needed one. With the 135mm Hexanon lens I could follow the action of these high school All Stars, and snap when I saw vigorous action. Shooting sports is a challenge to your sense of timing, and it is good technique to shoot plenty of pictures from which to choose the best. I've often said to people who asked why I shot so many rolls on a job, "I get quality from quantity." Since it was a night game I set the film speed dial at ASA 1000 and developed my Tri-X in Acufine, an excellent high energy developer. Exposure was 1/250 sec. at about *f*/5.6, which varied to *f*/4.5 when the players moved into a darker area. Konica automatic exposure is also a joy at plays, prize fights, and other events where you must shoot from a distance.

Figure 8. At the same football game, my son Barry Jacobs, age 12, used one of my Konicas fitted with the Hexanon 80~200mm zoom lens—which he allowed me to borrow from time to time! We had discussed the zoom-blur effect explained

earlier, and he gave it a try with this interesting result. In brief review, during a fairly long exposure (1/15 sec. or longer), you twist the zoom ring of the lens one way or the other to get the moving image at unpredictable blurs on the film. Barry's effort turned a routine shot of the players into an exciting picture.

Figure 9. The scene was an outdoor wedding. Quite untraditionally, the bride and groom socialized before the ceremony, and guests joined them. I caught this look on the bride-to-be's face almost by accident. I had pivoted from shooting another group to see this momentary look of love—and I fired. It was a horizontal frame from which I cropped this segment. Had I needed even a second to check or compute exposure for a change of light, her expression would have vanished, or I may have been frustrated with a badly exposed negative. All of which

points up the Konica's ability to be ready for that "decisive moment," a term that is so well dramatized by Henri Cartier-Bresson in his book of the same title published several decades ago.

Figure 10. Extreme closeups can be both useful and fulfilling to shoot. Nature studies, small objects, details of texture, all of these and more are apt subjects. Attachment lenses, extension rings, bellows, etc., have been discussed in Chapter 6, but the Macro-Hexanon AR 55mm $f/3.5$ lens is designed specifically to make closeup photography a pleasure. Its helicoid barrel allows the lens to move more than 1½ inches forward, and its 1× adaptor makes 1:1 images easy on the EE setting as well. Both the Macro-Hexanon and the adaptor were used to photograph the small green bug (probably ⅜ inches long) on a leaf in sunlight. Focusing was exact, for even at $f/16$ depth of field is minimal for extreme closeups.

Figure 11. Using floodlights indoors can be somewhat annoying, because it takes time, and there are wires to trip over. But floods provide continuous illumination you can evaluate and adjust, in comparison to flash or electronic flash. Fast black-and-white or tungsten-type color films work well with No. 2 photofloods or No. 2 bulbs rated at 3200 K (for Type B emulsions). You probably need to direct the lights at the subjects to achieve enough intensity for color films, but floods can be bounced when shooting black-and-white, as this scene demonstrates. My Tri-X was rated at ASA 1000, and two floodbulbs were bounced against a white ceiling. One light can be seen in the center background, and the other was at camera right, out of the picture. As I have mentioned before, bounced light is soft and evenly distributed. In this living room it was easy to move about taking wide-angle pictures such as this, or small groups of delighted chilren who were not squinting. Shutter speed was 1/60 sec., and the Hexanon AR 35mm lens was set about ƒ/6.3—by the EE system, of course.

Figure 12. This still life by Eleanor Bralver presented the exposure problem discussed in Chapter 4: a predominantly dark background. Mrs. Bralver (a high school teacher) lighted her illustration with two floodlights over which she put fiberglass diffusers to soften the light and practically eliminate shadows. With Plus-X in her Konica Autoreflex, and shutter speed set at 1/30 sec. (camera on a tripod), the indicated aperture was $f/8$. She made several exposures at this setting before doubling the film speed setting to ASA 250 in order to compensate for the amount of black in the still life. She also set the film speed at ASA 200, and the negatives shot at this rating proved most printable. Negatives were somewhat too dense (overexposed) at ASA 125, and slightly thin (underexposed) at ASA 250, though acceptable prints could have been made from all the frames she shot.

Figure 13. I asked my model to float near the deep end of the pool, close enough to the underwater light to get modeling and contrast on her body. I was intrigued with the sharp delineation of light and shadow, due to the spotlight-like quality of the pool light. Using a 28mm Hexanon to get a wide enough image from the edge of the pool, I shot at 1/60 sec. The Konica EE system chose *f*/4.5, which was "right on" as I discovered when the Tri-X (rated at ASA 400) was developed and printed. This picture could well have been shot in color on High Speed Ektachrome, for instance, which can be rated at 2½ times its normal speed for special boosted processing by Eastman Kodak Company, or a custom color lab. At boosted ratings, High Speed Ektachrome daylight type is ASA 400, and Type B is ASA 320.

Figure 14. The more opportunities you seek for photographic adventure, the more frequently you'll find yourself "too close in" for even the normal 52mm or 57mm Hexanon lens. Three wide-angle focal lengths expand your view in such situations, and

this one at the Ontario (Calif.) Motor Speedway called for the 21mm Hexanon lens. As part of my coverage of a race, I was assigned to include the spectators in groups, individually and en masse. At $f/16$ and $1/500$ sec. my depth of field was complete from the step in front to the tiny figures atop the stands. I merely set the focus at 3½ feet, and the depth-of-field scale on the lens barrel indicated that sharp focus extended from almost

two feet to infinity. This is often an expedient way to shoot with a wide-angle lens, especially in sunlight.

Figure 15. Though the Konica Autoreflex is mechanically designed to prevent double exposures, there may be times when you want two or more images blended on the same frame of color or black-and-white for pictorial effect. The technique is tricky and not fully predictable, but as this intentional double exposure by my son Barry demonstrates, the result can be strange and striking. Here is how you go about making a double exposure with the Konica:

1. Set the film speed dial at *twice* the normal rating; in this way only half the image density is recorded on the film by each exposure, and the total is then normal density for the double image.

2. Turn the rewind knob gently to tighten the roll of film and take up any slack. This helps, but does not guarantee, the registry of one image directly over the other.

3. Shoot the first picture of your double exposure. Barry photographed the racing car model on a plain background.

4. Press the film rewind button on the bottom of the camera until it clicks in firmly.

5. Turn the film advance normally while holding the rewind knob to prevent it from turning. This will cock the shutter, but the film will not advance because the rewind button is in. However, cocking the shutter returns the rewind button to its outward position.

6. Shoot the second picture, plotting the main elements of first and second images in your mind to affect a harmonious overlap. This is easier said than done. Barry shot grass and plants for the overall pattern, which, blended with the car image, produced a kind of ghostly effect.

7. Advance the film again normally and repeat the process for additional double exposures. Remember to return film speed rating to normal when you finish this little caper.

The Konica assures proper exposure, but since the camera is not designed for such techniques, images do not fall exactly

in register. Color film may be returned unmounted because the processor does not wish to cut between frames, since there may be part of an image in the usually blank margins. However, you can easily mount these slides yourself in cardboard or slip-in plastic mounts, after deciding where to crop them.

Intentional double exposures can also be made by sandwiching two slides, having two printed as one, or printing two images on one sheet of paper. You have more control in overlapping images outside the camera, but the excitement of the beautiful accident—that you planned all along—comes with chancing double exposures within the camera.

Remember: your pictures will be welcomed for a new edition of this book—provided they were taken with a Konica Autoreflex, of course. Better include the serial number of your camera with submissions—and thanks.

Index